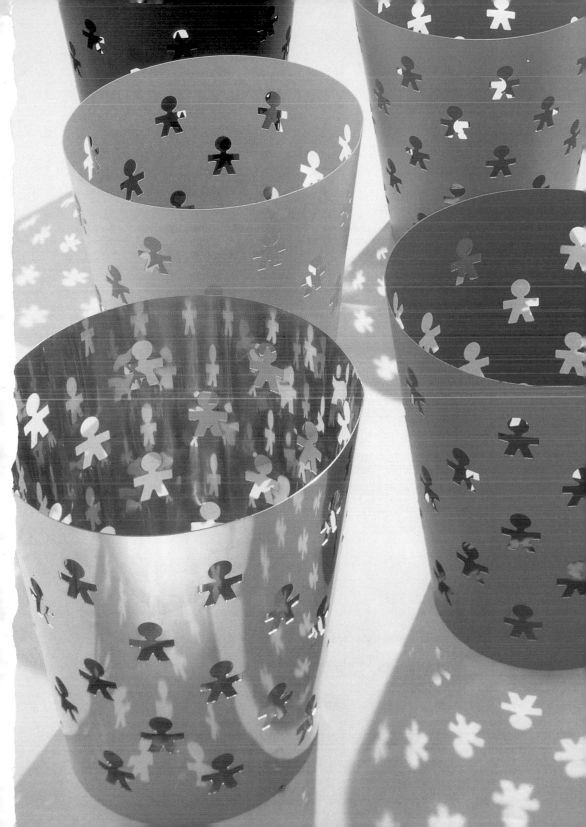

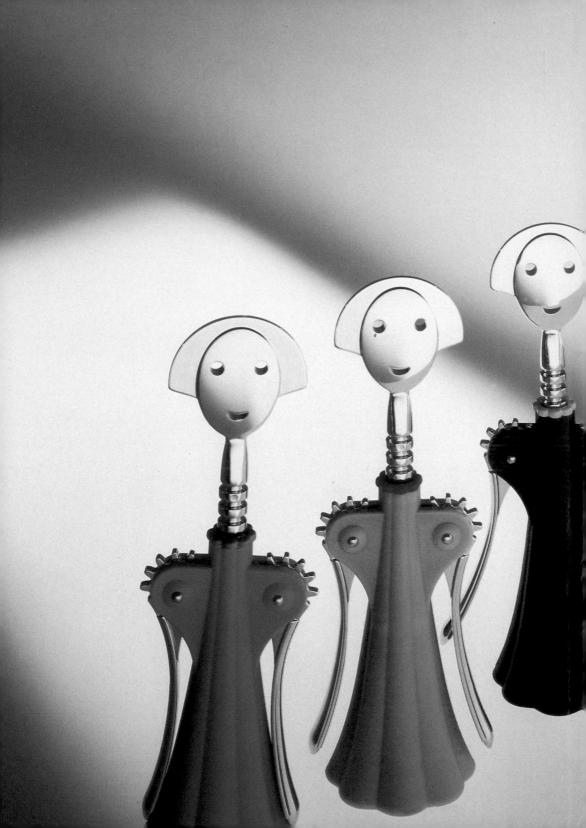

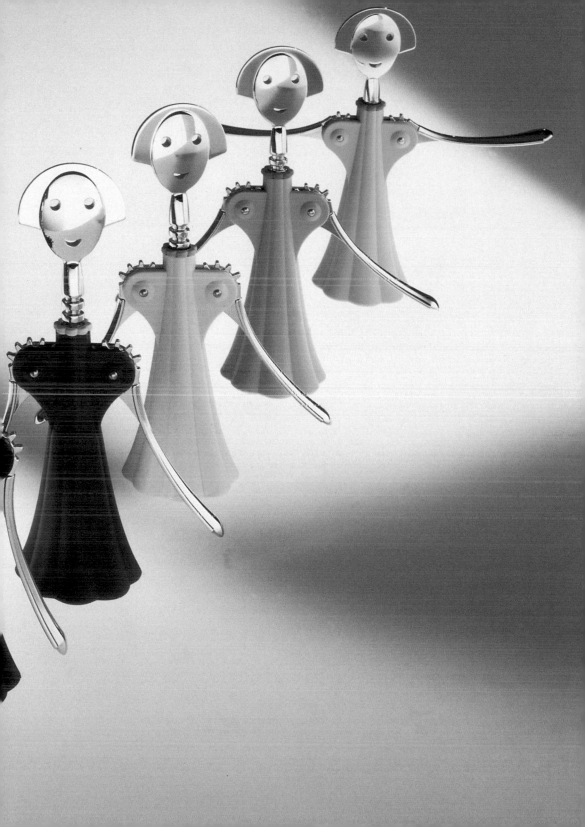

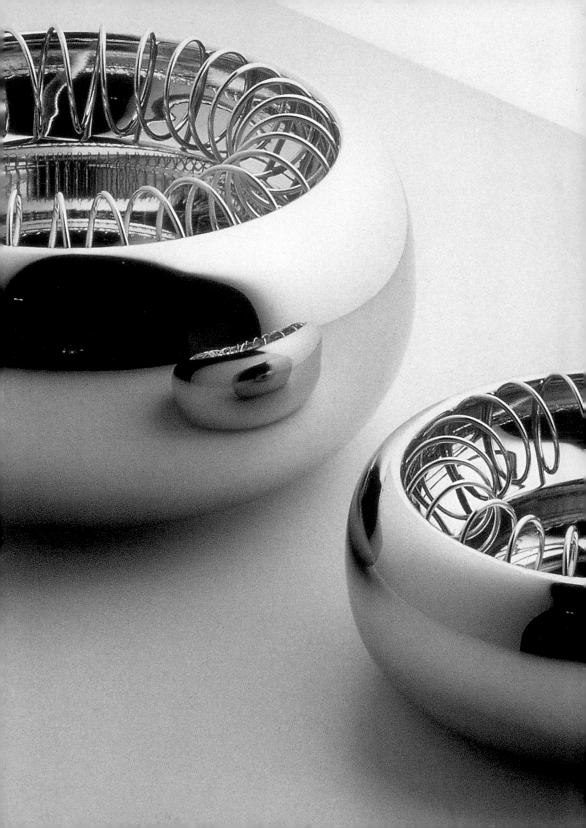

Alessi

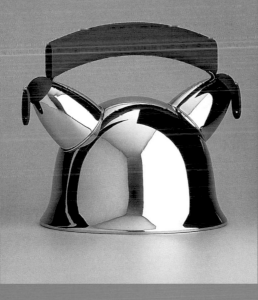

In memory of my father, Bernard Collins, 1911–1997

THIS IS A CARLTON BOOK

Text and design copyright © 1999 Carlton Books Limited

This edition published by Carlton Books Limited 1999
20 St Anne's Court
Wardour Street
London
W1V 3AW

A CIP catalogue for this book is available from the British Library

ISBN 1 85868 737 3

EXECUTIVE EDITOR: Sarah Larter
MANAGING ART EDITOR: Zoë Mercer
DESIGN: Simon Mercer
PICTURE RESEARCH: Deborah Fioravanti
PRODUCTION: Alexia Turner

Printed and bound in Dubai

Alessi

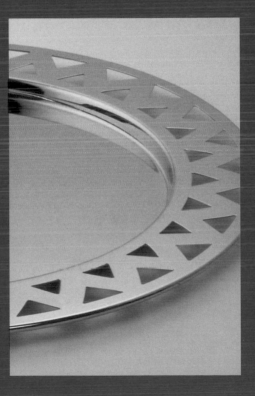

MICHAEL COLLINS

CARLTON

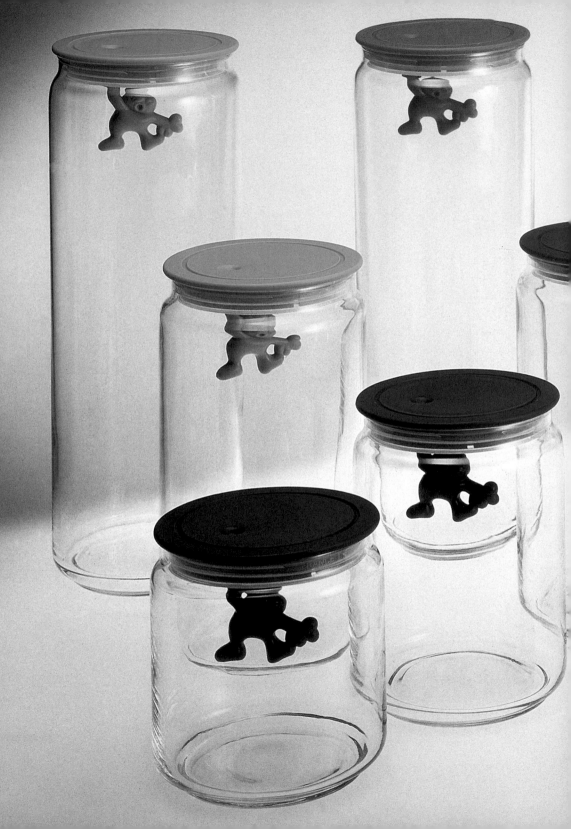

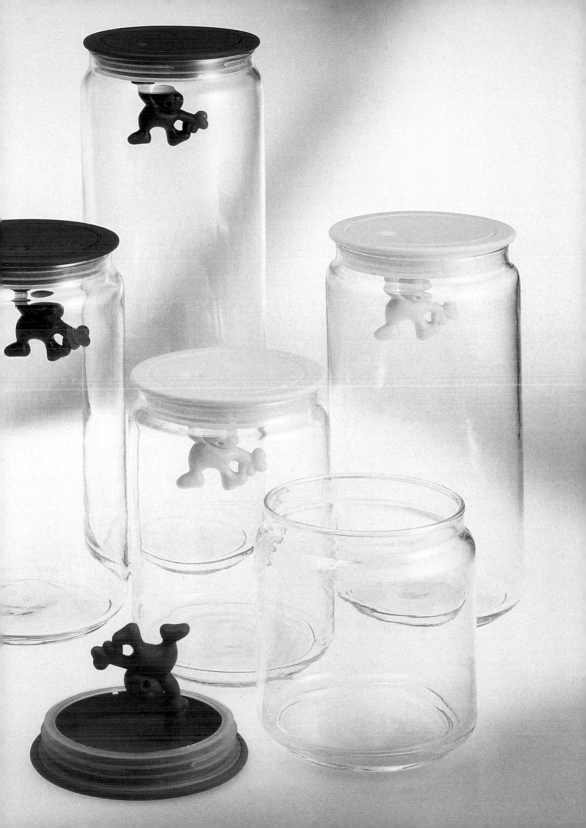

The extended and sometimes (dys) functional family in the kit(s)chen following fiction.

" ... AS THE **expertness** OF A CUSTOMER **declines**, THE IMPORTANCE OF HIS TASTE INCREASES – BOTH FOR HIM AND FOR THE MANUFACTURER. FOR THE CONSUMER IT HAS THE VALUE OF A MORE OR LESS ELABORATE MASKING OF HIS LACK OF EXPERTNESS. ITS VALUE TO THE MANUFACTURER IS A **fresh stimulus** TO CONSUMPTION WHICH IN SOME CASES IS SATISFIED AT THE EXPENSE OF OTHER REQUIREMENTS OF CONSUMPTION THE MANUFACTURER WOULD FIND **more costly** TO MEET ",

WALTER BENJAMIN, 1938 (1)

Let us examine the Philippe Starck lemon squeezer, *Juicy Salif*, of 1990. Let us purchase the Starck juicer, for it is the most economical way of having Philippe Starck for dinner, or rather for dinner in our kitchen where we now eat. We are kit(s)chen people.

Let us not use our Juicy Salif. Its use is not to be used. It is to be admired but as with art, "Do not touch". It is to be analysed and debated. Be careful if we do use our Juicy Salif. Does it matter that it transmits dribbles of lemon juice down its arachnoid head less well than a thousand year old oriental drain, made of chains, will transmit rainwater from a roof

A L E S S I

to the ground? Does it matter that the citric acid will eventually corrode the aluminium body of our arachnid three-legged pet from outer space? Does it matter that the downward pressure required to anoint its head with lemon will transmit such force as to tilt its three legs, and make its sharp feet dig into our wooden kitchen table? No, for we have a Philippe Starck, the Philippe Starck in our homes and hearts. Does it matter that our old anonymous glass juicer will perform the task just as well, if not better? No, for we have a Philippe Starck in our kitchen!

Let us photograph this Juicy Salif, for it has been designed to be photographed. It is more photogenic than its author. Let it be photographed in elevation, with a lemon on its head, like a hat at a jaunty angle, in the 1990 Alessi catalogue. Let four Juicy Salifs be together, three in echelon and one alone, with long cast shadows on a grey surface, for the cover of the same catalogue.

Let the whole Alessi family be photographed (6 men – are there no women?) each with their Juicy Salif, for the introduction to Alberto Alessi's book *The Dream Factory*, of 1998. Carlo Alessi, son of the founder Giovanni; his brother Ettore; Carlo's nephew Stephano and Carlo's three sons, who now run the enterprise, Alberto, Michele and Alessio.

The company was founded in 1921 by Giovanni Alessi, and its first factory was in Omegna, at the north of the dreamy Italian lake, Lake Orta. From the first they were metal manufacturers, using brass, electroplate and nickel silver. In 1928 the firm removed to Crusinello and has remained there ever since. Alessi made durable kitchen and table ware; machine pressing of metal began in 1930. Chromium plating was innovated, typical to the 1920s and 1930s; stainless steel was employed from 1938, in parallel to its innovation by better-known firms such as Jensen of Copenhagen. In the 1930s design was done "in house" by Carlo Alessi, elder son of the founder Giovanni Alessi. Carlo had studied industrial design in Novaro and joined the company in 1932. His presence reinforced an

ALESSI

aspect which has become the leitmotif of Alessi to this day, that is the "family" aspect of the enterprise. Indeed after the interruption of the war, Carlo Alessi designed the firm's first "classic", the Bombé tea and coffee set of 1945, which is still produced today in electro-plated stainless steel, with applewood handles and knobs. Its origin is significantly remembered in family terms, and Carlo Alessi has stated that "in 1945, when I used to go to visit my fiancée, my present wife, they would bring porcelain teapots, milk-jugs and cups when they offered me tea. One day I put a milk jug that I liked in my pocket: I developed this design, and the shape of the Bombé set was born. I liked its outline". (2) Interestingly, it was originally produced in nickel silver with bakelite handles; an early and logical use of the plastics that now so dominate attention in the 1990s. Such simple and self-effacing "in house" design continued into the 1950s; it was only in 1954 that external "consultant" designers, such as Carlo Mazzeri, Luigi Massoni and Anselmo Vitale were brought in. This was at the instigation of Ettore Alessi, Carlo's younger brother, who joined the firm in 1945, as head of the technical department.

These designs were mainly for the hotel and the catering trade, and although the Alessi firm began to receive wider recognition in the 1950s and 1960s, it had a limited profile. Indeed no mention at all was made of Alessi by Graham Hughes in his excellent survey *Modern Silver*, 1967 (which comprehensively covered electroplate and stainless steel as well). The company's profile changed with the appointment of Alberto Alessi, Carlo's son, to the company in 1970. Alberto had read law in Milan, but the call to the family firm was greater. It was in the decade of the 1970s that high profile designers such as Achille Castiglioni (1970) and Ettore Sottsass Jnr (1972) were consulted to achieve the "take off" period that has now led to Alessi being synonymous with the best of kitchen utensil and hardware design. Both Castiglioni and Sottsass have continued intermittently to produce excellent work for Alessi. Indeed some of Sottsass' best designs, such as those for condiments between 1974 to 1978 have remained solid sellers. They make little noise in the catalogue, and indeed have often been sold "anonymously" (that is without the famous Sottsass tag attached) in kitchen and hardware shops in Italy.

From this solid and sensible base, Alessi added the big "maestro" name of Richard Sapper to its growing list, in 1977. Sapper's Espresso pot in stainless steel, *9090*, designed for Alessi in 1978 and made in 1979, contoured Alessi's profile through winning the XIth

Compasso d'Oro award in 1979; it was also acquired for the Design Collection at New York's MOMA. This was Alessi's first espresso pot and their first item both to win prizes and enter the arena of the museum collection. By 1985, the 9090 was in Museums in New York, Louisiana, Philadelphia, Berlin, Dusseldorf, Zurich and Jerusalem.

In just two years, from being "off the map" in Graham Hughes' exhaustively researched survey Alessi had "arrived", by 1979, into the world of bankable international prize and museum recognition. 1979 was also the year of the election of Margaret Thatcher, Ronald Reagan following in 1980, with the beginning of a neo-conservatism in politics and a Postmodernism in Architecture.

Key to this "arrival" is the role of Alessandro Mendini, the guru, consultant, adviser, and historian of the firm since 1977, as well as its occasional designer. The part played by Mendini is in danger of being marginalized, as, in the 1990s, Alberto Alessi assumes the kingly position. If Alberto is the king, Mendini is the kingmaker. As Mendini himself said in 1984 "when I began as consultant to the firm the forms of the past were being re-examined, in order to create a philological base ... before this historical revision the Alessi style was extremely fragmentary and in some aspects inferior ..." (3). Medini became what Alberto Alessi calls Alessi's "official chronicler" when he wrote the history of Alessi, *Paesaggio Casalingo* in 1979 with its attendant exhibition, designed by the Austrian Postmodern architect Hans Hollein, at the Milanese Triennale of the same year. Also in the same year Mendini developed a research unit to enable architects and designers to debate neo-modernism and postmodernism. The project was called *P6*, (renamed *Tea and Coffee Piazza services* by Bruno Munari, the designer of the catalogue) and the resulting services by Neo-modernists such as Mendini himself, and Postmodernists such as Michael Graves, Hollein and Robert Venturi received huge media attention. The new trade mark, Officina Alessi, was set up accordingly, with graphics and images co-ordinated by Ettore Sottsass Jnr. and Sottsass Associati.

Mendini, as co-ordinator of the Tea and Coffee Piazza project had thrust Alessi into the centre of the furious debate about postmodern design, as well as extending the "family" of designers to Americans, such as Venturi and Graves. By the time the sets were produced in 1983, Alessi had ousted Rosenthal from its premier position as the cutting edge design firm, and had centred metalwork as the material for innovative design. Alessi were also part

of a cultural shift away from German concepts of design, towards an inflamed debate which had been present from the era of Pop Art, which had centered on Mendini's native city, Milan, itself only 60 miles south of Alessi's Crusinallo. The Tea and Coffee Piazza sets themselves were somewhat to Alessi as the Portland Vase had been to Josiah Wedgwood – expensive "loss leaders" that gathered critical and cultural momentum for the firm. Looking back, they seem like an expensive group of couturier's clothes on the catwalk of Postmodern design. Michael Graves's set was for example admired by Nancy Reagan at the Whitney Museum's "High Styles" exhibition in 1983, cost £11,390 in 1986, and like all the other sets was made in a limited edition of 99, plus 3 "artist's proofs". Design had never quite imitated art so much as it did then. And, as with the proof in the print market, there follows the cliché; as with the expensive couturier's item, there follows the diffusion range. Alessi tapped into the fashion and art market systems by following up these catwalk eyecatchers with, in the case of Graves, the famous kettle with the whistling bird of 1985, which sold over 40,000 in one year, despite being technologically to the rear of Peter Behrens' electric kettle, marketed before 1910! The work achieved by Graves for Alessi is fairly typical of the 1980s, in that, as Alberto Alessi has written "it spawned a "family" of objects which Graves dauntlessly continues to expand, year after year." (4)

Graves, in turn has reciprocated by stating that "with Alessi, tradition extends to the idea of the family. As a designer you and your people are brought in and treated as a member of a family". (5) Perhaps Michael Graves has not noticed that on a literal level, his name is not on the artefact? The kettles are stamped with the Alessi name, but not that of Graves. This also applied to other best-sellers of the 1980s such as Aldo Rossi's coffee pots and Philippe Starck's Juicy Salif. As with Wedgwood, who only allowed his name and that of his partner Bentley on his ceramics – nothing is signed by John Flaxman for example – we get a sense from this that the manufacturer retains the ultimate control. In absenting the signature or credit on the artefact itself, but encouraging it on the packaging or endless literature, we also sense that the artefact has become a mere adjunct in a longer process of research, development, publicity and packaging. In this way the designer's work is "autographed" not through the end product, but through a process that takes the consumer back, through relentless publicity and promotion to the factory and "authority" of Alessi itself.

Though the debate of the years 1979 to 1987 and the beginning of recession were

centred on the issues of Postmodernism, Alessi as an enterprise had managed to become a major manufacturer partly as a result of those debates. There are very few eponyms in design history; "Wedgwood" is used to describe any blue and white ceramic in Europe; "Liberty" has come to mean Art Nouveau in Italy, and "to hoover", meaning to vacuum clean, is an English expression (though not an American one). While not yet eponymous, Alessi became synonymous with Postmodern design more than any other enterprise. Consumers came to expect challenging design from an increasing list of predominantly male, architect "maestros" (the word itself contains gendered language – the master). By 1985 the list of designers for Alessi bristled with "authority" or rather its aura, since the ultimate authority had been invested in the company itself. This list included Achille Castiglioni, Riccardo Dalisi, Michael Graves, Hans Hollein, Vico Magistretti, Richard Sapper, Richard Meier, Alessando Mendini, Bruno Munari, Paolo Portoghesi, Aldo Rossi, Ettore Sottsass, Stanley Tigerman, Oscar Tusquets and Robert Venturi; by 1986 it had extended to include Philippe Starck. It was perhaps the gathering strength of Postmodern design with its historical inflection that caused Alessi to develop a programme of research into historical metalwork, with a particular slant towards the so-called "Pioneers of Modern Design" who feature in Sir Nikolaus Pevsner's now controversial book of 1936 of the same name. Literature in the 1980s surrounding Alessi, particularly Patricia Scarzella's *Steel and Style*, of 1987 also began the process of locating Alessi into a longer and more significant pre-history extending back to Christopher Dresser, Josef Hoffmann and the Wiener Werkstätte and the metalwork studio of the Bauhaus, with a particular interest in Marianne Brandt's work. Two American architects, Peter Arnell and Ted Bickford "reconstructed" a dish with conventionalized rose perforation, designed by Josef Hoffmann in 1906 for The Wiener Werkstätte, but which only existed in photographic form. The result was the *Rosenschale* basket of 1983, produced in electroplated brass. While it is quite clear that there was a growing interest, particularly in America, for products of the Werkstätte, the introduction of such as artefact is highly controversial. By producing a "museum" artefact, Alessi were by implication repositioning their own contemporary work into museum status. Here again, the family analogy holds, only in this case the search for roots seemed to be both psychological and marketable. Jean Baudrillard has perceived that a fascination with consumer objects from history is an attempt to regress to childhood and find Mother

(origins) and Father (authenticity). The application of a Baudrillard-based deconstruction of Alessi seems appropriate in response to Alberto Alessi's own appropriation of the language of the family in subsequent literature, interviews, and his own writing in *The Dream Factory*.

This seemingly psychological quest for Baudrillard's "authenticity" and "origins" within artefacts from the past has been reinforced in the Officina Alessi *Archivi* series which began in 1985 with the production, under licence from the Bauhaus-Archiv in Berlin of a tea and coffee set first designed by Marianne Brandt when she was working in the Bauhaus metalwork studio between 1924 and 1930. Perhaps this served to locate the "Mother" and "origins" in one gesture. It is significant that amid a host of photographs of male designers, the photograph of Brandt in *The Dream Factory* is the sole reminder of the, albeit posthumous, presence of a female designer. As will be discussed later, Alessi has attempted to redress this gender imbalance in the 1990s.

If Brandt's "presence" may serve Baudrillard's uncanny search for "origins" then the revival of Christopher Dresser's metalwork in 1991 may be seen as resolving the quest for "Father" and "Authenticity". A suite of Dresser's designs from the 1878 to about 1885 have been "reproduced" from original examples from the collection of one London dealer. There are several problems attached to this form of "authentication" of history in terms of selection and material used. The perception that one gets from the artefacts made after Dresser in 1991 is as slanted as Pevsner's view in the 1930s that Dresser was a pioneer of modern design. The absence of Dresser's more eclectic and historicist work simply reinforces a determinist view of design history, and tells only a partial truth. Again, in terms of Baudrillard, if this is a search for the "father" the resultant Alessi artefacts find a father censored of his errors and quirks. This may be expected because it is a metallic perception of a designer who worked, often using far more ornament, to design textiles, ceramics, and glass as well. The most curious distortion has also led to Alessi's initial production (as with other *Archivi* metalwork) of Dresser's metalwork in silver. Dresser's metalwork was emphatically designed to be made in electroplated nickel silver. It was thus designed for mass-production and not to be made as Alessi have done in "99 copies plus 3 artist's proofs" as they state in their catalogue of 1992. The word "artist's proof" would have betrayed Dresser's well recorded claim that he was a "designer" and not an "artist". Perhaps more sensibly, Alessi also issued a toast rack after Dresser's design of 1878, in

1991, and produced this in stainless steel, a material more logical to Dresser's intention, though of course not available in 1878.

While it is clear that these *Archivi* reproductions satisfy the needs of educated collectors (as opposed to the usual customers for Alessi) they also underline the constant Alessi quest for acceptance within the higher world of the museum. These artefacts are to all intents and purposes "museum reproductions" and in the case of Brandt's work they are achieved under license, from the Bauhaus-Archiv. They have served to "locate" Alessi within a longer history, especially of metalwork. Such "reproductions" also look very curious now, at the end of the 1990s , a decade which has seen Alessi alter its attachment to metal, and diversity into ceramics, wood, and plastics.

The *Archivi* series was above all an example of the themed range developed in the 1980s. Perhaps the most sensible of these was *La Cintura di Orione*, a research project developed from 1979 by Alessi, which encouraged the collaboration of designer and chefs in the quest for more ideal cooking utensils. The "think tank" created involved the collaboration of the designer Richard Sapper, and the gourmet Alberto Gozzi, with carefully selected chefs Alain Chapel, Gualtiero Marchesi, Angelo Paracucchi, Raymond Thuilier and Jean-André Charial, Pierre and Michel Troisgros and Roger Vergé. This research led to the production of some of the best stockpots, casseroles and colanders ever made, and are a testimony to Alessi's capacity for intelligent research and development. The range of utensils designed by Richard Sapper in 1984, in collaboration with Marchesi, and made from 1986 are examples of how a "*maestro*" designer may work with a "*maestro*" chef to produce simple and sensible results. Here is a "big name" collaboration between one of Italy's best product designers, Sapper and Marchesi, Milan's riposte to nouvelle cuisine, and in the 1990s, the chef who put the Halkin in Halkin Street, London onto the map of cuisine in Britain. The contributions from the other chefs such as Pierre and Michel Troisgros, who are also darlings of the *nouvelle cuisine* set, are also equally rewarding. In total, the products are the summary of achievements of an exciting research programme to redevelop existing typologies of cooking utensils and refine them in consultation and collaboration. Alessi have always worked at their best from the high ground of research and development of metallic artefacts. If there is a criticism, then it is that, typically, the project was entirely male-authored and assumed that the (male) authority of designer and chef was enough to

satisfy the project brief. Don't women cook? This is reinforced by the gendered language employed to describe the chefs as "*autorita*" "*maestri lionesi*", "*Grande interprete*" and "*Lo chef*". In retrospect this collaboration between designer and chef could be seen as a perfect mirror held up to reflect the culture of the 1980s just before the recession of 1987.

This was an era parodied so well in a British situation comedy, "Absolutely Fabulous", which cast a designer-conscious pair of women "of uncertain age" against the foil of a conservative daughter of one of them. Perhaps significantly, the *mise-en-scène* was largely that of the kitchen, and most remembered line was the character Patsy's (actress Joanna Lumley) parody of the era's fascination with designer clothes with the phrase "names, darling, names". Rather significantly for Alessi, the world of designer-names, expensive dinners and Postmodernism were all stuck hard by the recession of 1987. The 1980s had been years of plenty, but the economic uncertainty after 1987 reduced the amount people were prepared to spend on food, clothes and design. House prices declined and there were bankruptcies in all sectors. Cheque books were locked away in drawers.

Alessi's response seems, in retrospect, to have been geared towards a change of direction that has involved key new elements: further research; diversification of its material base in metals towards plastics, wood and ceramics; an attempt to redress gender balance through positive discrimination, and a daring attempt to capture the lower, youth-cultural element of the market, with some concessions to current issues including ecology and sustainability. The problem is that none of these are fully resolved and as topics they can only been seen as "work in progress". After a decade some assessment may be made.

Some of the more vital developments are still the result of the catalytic presence of Mendini. In 1990 the Alessi Research Centre was established in Milan, where it remained until 1998, moving back to Crusinallo. Mendini suggested the appointment of the first woman to contribute to Alessi's research on any serious level, Laura Polinoro. As always Mendini drew up one of his "conceptual diagrams" for the project which attempted to embrace concepts such as "sea of objects" "forms, typologies and psyche", "global expectations" and the ultimate user as "customers". Laura Polinaro has refined some of these issues, and as Alberto Alessi has written "through her we have brought new disciplines to bear at Alessi, anthropology and semiology to name but two." (6)

Alberto Alessi has also deployed his own thinking, derived from two texts: Franco

Fornari's *The Good Internal Family,* and D.W. Winnicott's *Playing and Reality*, 1971. Alberto is fond of quoting Fornari's "theory of emotional codes". Fornari had suggested that some of our choices are dictated by emotion and fantasy, the "state of the night" (as opposed to the "state of the day" – utility and reason.) Alberto Alessi has evolved Fornari's theory of paternal and maternal codes by applying his own reasoning to suggest that "consumer society is dominated by the imperialism of the child code: the consumer, an omnipotent and privileged child, whose parents reverently bow to his or her wishes". (7)

Winnicott's theories have also examined dream and reality, and identified "transitional phenomena" and "transitional objects" such as toys. Winnicott has also suggested that we continue to use childhood objects in our formulation of identity. Much of Alessi's output of the 1990s has been presented against this background which emphasizes childhood and its associations, and links this inflection to a new "generation". Perhaps the first of this new work was produced by King-Kong, the *nomme de guerre* of two young Florentine architects, Stefano Giovannoni and Guido Venturini. They formed a bridge between the Alessi of the 1980s and the new Alessi of the 1990s; both were introduced in the late 1980s by Mendini, who has throughout been a enabler of much new talent. They had taken the intervention of paper chain cut outs (and perhaps the simple pierced forms in children's toys) to produce the Girotondo tray. This first work, designed between 1989 and 1990 didn't look out of place in the 1990 catalogue. As a round steel tray, coloured by baked-on coating of black epoxy resin, with its "cut out" motif of a conventionalized figure it sat fairly happily opposite a photograph of a self-effacing tray of 1982 by Sottsass. Both were metal; both had more plain surface than decoration. The trajectory of King-Kong was however indicative of developments in the 1990s; a gradual extension of the "family" of cut-out men to embrace a multitude of artefacts, such as fruit bowls, toast racks and napkin rings. Alessi have gradually introduced less expensive items to widen their market, and the "King-Kong" series reflects a post-recessionary imperative to seize the cheaper, youth-cultural market. Though they are available in shiny metal, many are also coloured with epoxy resin, thereby seeming to reflect changes brought about in the automobile industry. It is almost impossible to find a car in the 1990s that has chromium plated bumpers or wing mirrors. It is as if Alessi has realized that we like to buy, but not to clean, our artefacts. Shiny metal is no longer so fashionable.

The series is also know as *Girotondo*, an Italian title equivalent to "ring-o-ring-o-roses". This appropriation of a nursery school title and infantile inspiration, from the paper cut-outs of children, is justified by Alberto Alessi as a "typical case of applying the 'child code' to a catalogue like ours, until then dominated by the authority and style of great designers' masterpieces; a counterweight to the then emerging talents of Rossi, Graves and Starck" (8). Alessi has also said they were spot on with the "playful style"and understood the importance of "emotional codes". Even the name "King-Kong" and its transference to the series title tapped into childhood memories of the lovable, pitiable and sexy oversized gorilla in the 1933 film classic of the same name.

Though the *King Kong* partnership dissolved in 1993, Venturini and Giovannoni have continued to design on an individual basis for Alessi. It is significant that the bulk of their work is for plastics and has a Rabelaisian quality of humour and the occasional scatological joke, such as in the title *Merdolino* for Giovannoni's lavatory brush holder of 1993. I have chosen my adjectives with care here, for they rather prove that this type of humour is not new; nor is "neo-kitsch'" which appeared as a phrase on one of Mendini's conceptual diagrams long before the 1990s. The same may be said for their "ludic" (playful) codes, which may seem new. Indeed the concept of "Homo Ludens" was defined, albeit in rather a more bourgeois manner by Johan Huizinga's book of the same title, published as long ago as 1938. "Homo Ludens" was also quoted by Philip Johnson as being an important element within (his) architecture in an interview during the 1986 BBC series "Architecture at the Crossroads". What seems to be fresh for a new generation perhaps, is the emphatic deployment of plastics to convey the transformation within Alessi. This has been encouraged by Alberto Alessi, who quotes Giovannoni as saying "but who is this Michael Graves? He's certainly not a designer!" (9) and allows both, as "King Kong" to exclaim:

" WE'VE HAD ENOUGH OF erudite DESIGNERS LIKE MENDINI OR BRANZI ... WE LIKE TO DESIGN THINGS THAT APPEAL TO ORDINARY FOLK. " (10).

The last statement is somewhat ungrateful, given that Mendini introduced them in the first place, but like so much art, it is about posturing, and it isn't new either – witness the Situationists calling Surrealism "the father we loved and the father we hated".

In essence many of these cultural shock tactics stem from ideas developed within the Alessi Research Centre; the next one was called *Family Follows Fiction*, realized between 1991–1993. It embraced a range of new work, primarily in garish plastics, by Mattia Di Rosa, for example. With these the ludic turns to the borderline of the ludicrous. They have been justified by the company in terms of psychology, but it takes a lot of psycho-babble to convince the Leavisite (*The Great Tradition*) wing that they are valid in terms other than the economic. By their audacity and cheekiness they also serve to relocate Alessi's Postmodern work, which was at times seen as resistant to Modernity, back into a canon that is ironically close to modern "good form". The presence of Christopher Dresser's ingenious three-legged sugar basin, transmogrified into a multitude of colourful plastic versions, and called *Christy*, ensures that the critics should be out in force. Though Dresser did apply humour to his design, and when he in 1864 penned out the original design was thinking of zoomorphic analogy for the legs, especially frog's legs, there is nothing "Christy" about Dr. Christopher Dresser. The sugar basin was originally designed in electroplate for a servanted society where the staff cleaned the metal work. Now in plastic it looks as if it's for the rumpus room to be cleared away with the rest of the toys.

Alessi are applying a more secret code of psychology here; if it annoys the critics, then it will get attention; at the same time, the general consumer won't care, and it is cheap to make, since the designer is dead and doesn't need to be paid.

The important thing about Mattia Di Rosa's work is that the products are fun and cheap. *Gianni,* a little plastic man holding on to the underside of the plastic cap inside a storage jar, of 1994, is a case in point. Alessi have cannily understood how the market has been dumbed down both economically and socially.

Alessi are aware that there has been a revival of interest in 1950s and 1960s plastics. They have reissued Enzo Mari's range of designs, first created for Danese in the 1960s, in the 1990s. These are solid intelligent designs; Mari had given serious thought to the design of plastics from the 1950s onwards, and his presence in the Alessi "family" sets up a borderline friction between his own "good form" Modern plastics and the ludic neo-kitsch

of 1990s Alessi work. At the same time his inclusion turns him into a *maestro* and father figure of the material, as if Alessi again need "authority" for their radical change towards new materials. In 1988–9 a range of wood-based designs *Twergi* was launched, and with this range Andrea Branzi produced designs which have a resonance with issues of ecology. In 1990 *Tendentse* was set up in Livorno to manufacture ceramics for Alessi, but some of the results, such as Mendini's *100% Make Up* project, which consisted of one basic shape by Mendini having 100 different designers apply surface decoration design to it repeats all the mistakes made by Doulton in the nineteenth century for example, the application of decoration sometimes designed by women, to a shape authored by a man.

A major criticism of Alessi has been the gender imbalance in favour of men. This has been redressed using positive discrimination in the *Creole* project of 1991, on the ritualistic theme of "serving and offering". 200 women designers under 30 were invited to participate and the results were first shown at the 1991 Salone del Mobile in Milan, with some valuable work by Clare Brass, Anna Gili and Maria Sanchez, among many others.

How does Alessi's work of the 1990s fit into a broader cultural shift? In 1987 Matei Calinescu in his book *Five Faces of Modernity* suggested that kitsch had:

"THE **power** TO PLEASE, TO SATISFY NOT ONLY THE EASIEST AND MOST WIDESPREAD POPULAR **AESTHETIC** NOSTALGIA, BUT ALSO THE MIDDLE CLASSES **vague ideal** OF BEAUTY WHICH STILL IS ... THE COMMANDING FACTOR IN MATTERS OF AESTHETIC **consumption** AND THEREFORE **production**." (11).

Gilbert Adair, in *The Independent* has written on how adults have been returned to infancy by visiting Disneyland: "grown-ups who accompanied us to the Disneys enjoyed them as much as we did ... it would have been as inconceivable for a grown up (in the past)

to think of going to see one unaccompanied by an infant as it would have been to buy dolly mixtures for his or her own consumption. Now, apparently, we all prefer dolly mixtures." (12). In *Faking It*,1998, Bruce S Cooper and Dennis O'Keeffe have suggested that "in recent decades, in both America and Britain, education has set aside discipline and obedience, and replaced them with false love and slackness ... if sentimentality once pervades education it will in time pervade everything else." (13)

Alessi's "make-over" in the 1990s may reflect this sentimental, neo-kitsch, Disney world of childhood tastes, but it also has a solid economic base, like Disney itself. Elizabeth Nickson, writing in *The Independent* has noted that "the advertising dollar aimed at children has increased from $100 million to $1 Billion dollars in less than 10 years." (14). At the time of writing Nintendo's Silicon Valley is being lavishly advertised in London telephone boxes. The market for children's taste has burgeoned.

The trajectory of some of Alessi's designers reflects this dumbing down of the market. Michael Graves brought fame to his practice and Alessi with his kettle of 1985, which has been praised as a solid, durable and therefore sustainable design, in a decade which has seen a growing awareness of the issue of sustainability. As Paul Goldberger has reported in *The New Yorker* in February 1999 "Graves has been designing household object for years – he is particularly well known for an Alessi teakettle with a whistling bird on the spout which retails for $145 – but he has never cracked the lower end of the market. Now that what might be called the Gap phenomenon, the trending downward of taste, has made mass-market goods more sophisticated, the time seems to have come for an internationally acclaimed architect to design $12.99 picture frames and a $39.99 toaster." (15) Indeed, Graves has agreed to design a new line for Target, the discount store chain with over 850 stores in America.

In America Alessi products are popular because of the *maestro* presence of designers such as Graves. Alessi products are on the internet now. They can be bought from firms such as DesignBuy which specializes in "Architecturally Designed Products". Its home page leads with Alessi: "welcome to DesignBuy, featuring Alessi and other fine architecturally designed products". "www. retromodern.com – the internet supersite for Twentieth Century Design" boasts that it "now stocks over 160 different designs from Alessi" including *Family Follows Fiction* which it calls "an innovative fun line developed in 1993",

"click on Diabolix bottle opener for over 30 fun items" and "Comix in the Kitchen" – "a whimsical line of napkins trays, mitts and placemats introduced in 1997". The existence of the internet will no doubt increase the demand for accessible, reasonably priced Alessi goods. Availability of its products on the internet is a reflection of the high profile achieved by Alessi in terms of publicity; consumers do not buy from the web unless they know what they are getting.

In conclusion, Alessi have proved to be the most innovative and controversial design factory since Rosenthal, which was acquired by Waterford Wedgwood in 1998. Now one might imagine with names such as Wedgwood and Rosenthal, described by *Investors Chronicle* as producers of "luxury crystal and ceramics" that it was the luxury end that fired the market; their company results indicate otherwise; the magazine reports that "New product ranges and sectors", such as Christmas tree decoration and millennium toast flutes, boosted a growing core business". (16) Alessi are part of this larger economic system in the 1990s where the phrase "bottom line" has an ambiguous resonance.

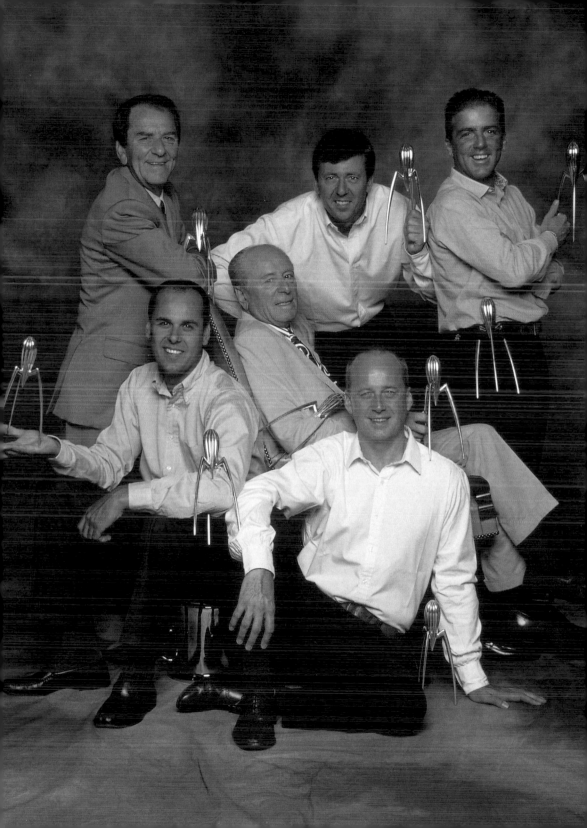

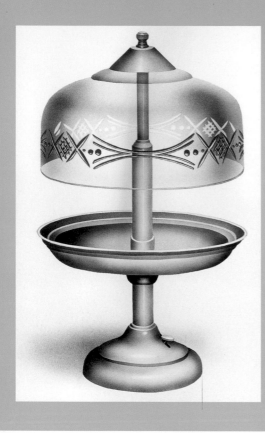

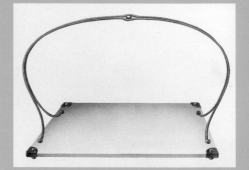

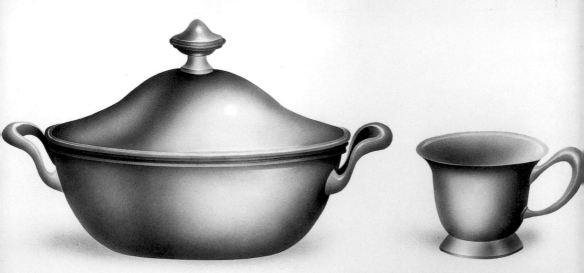

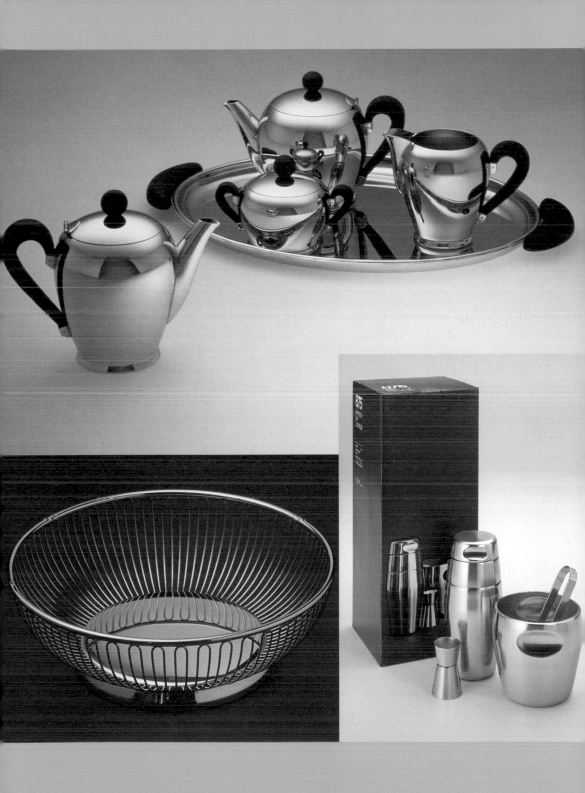

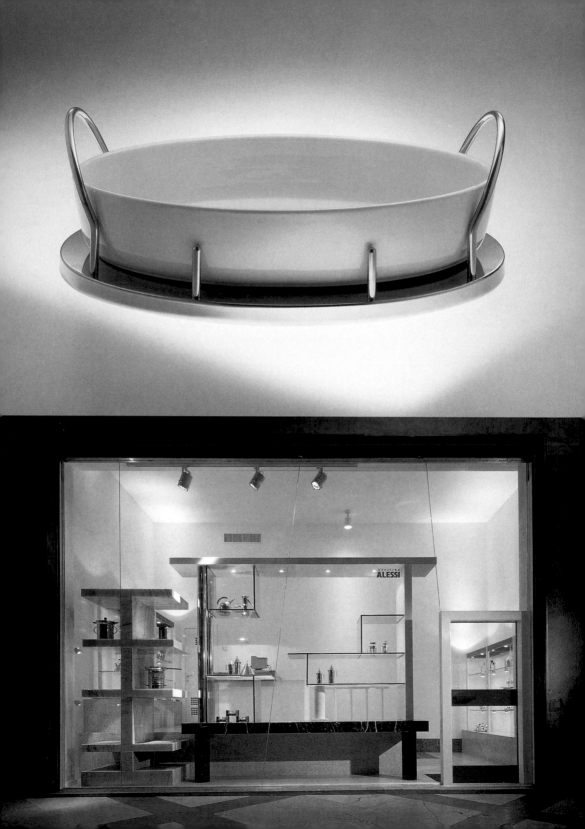

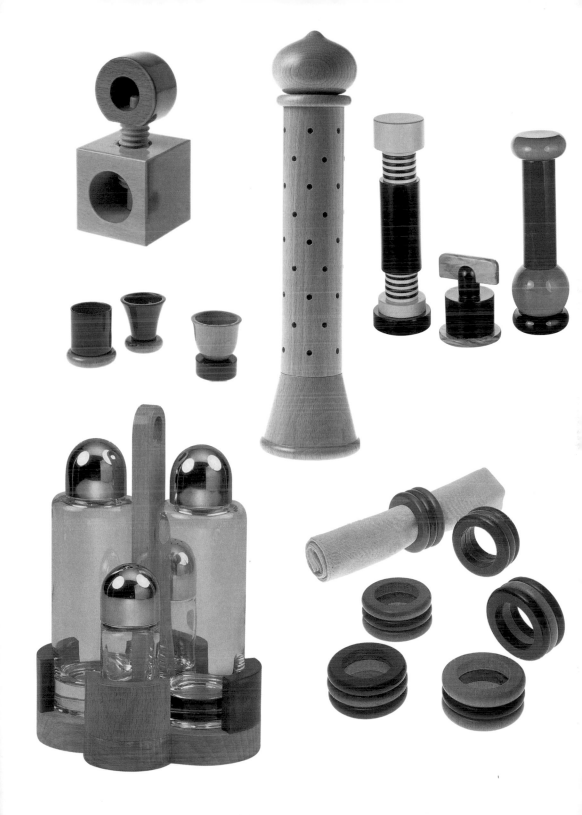

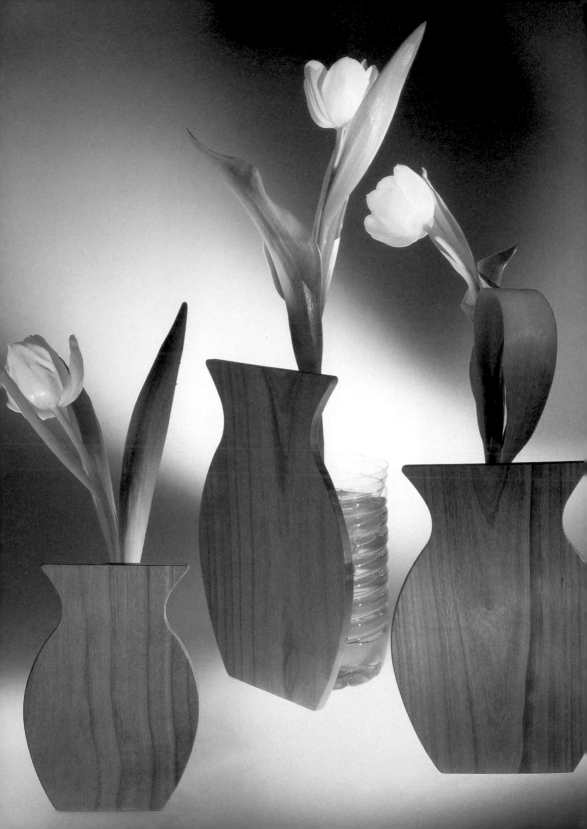

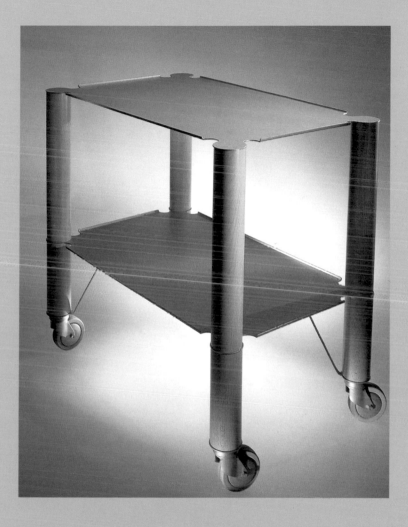

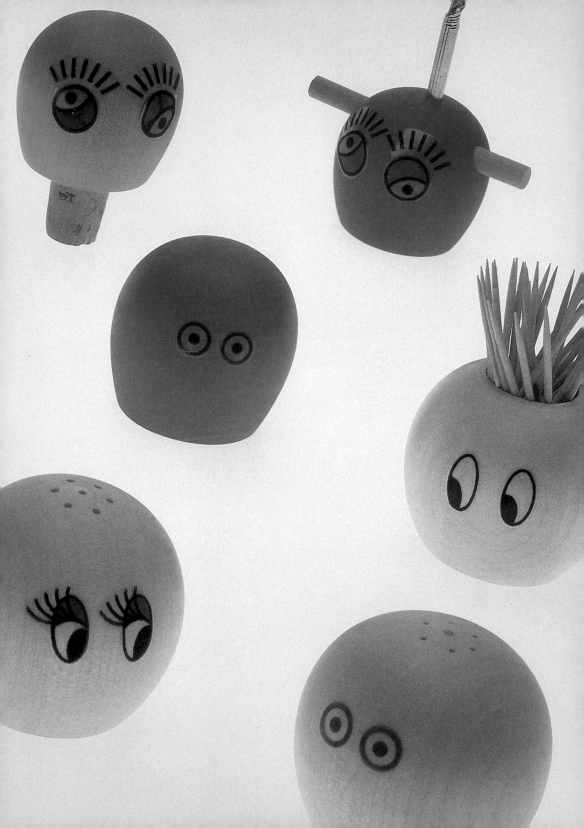

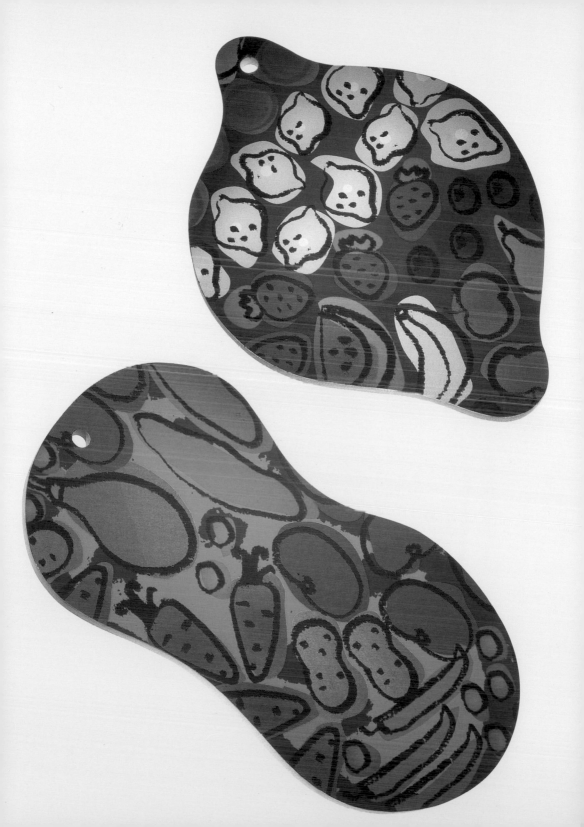

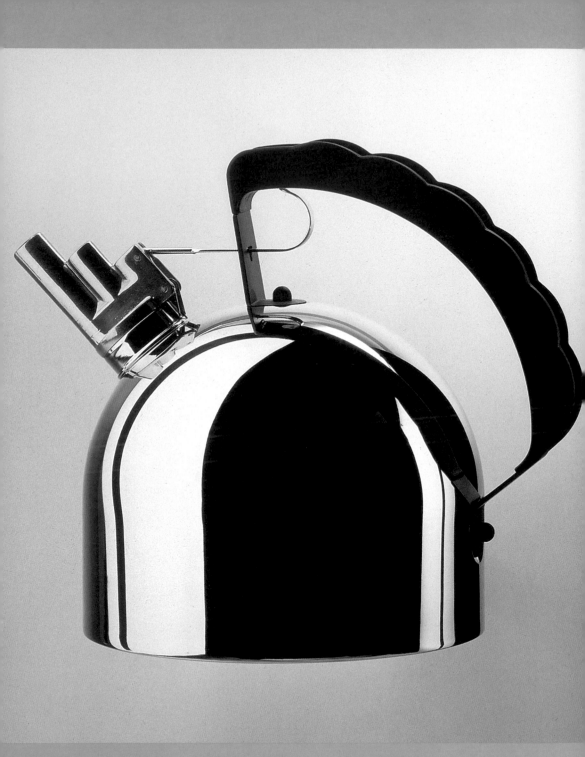

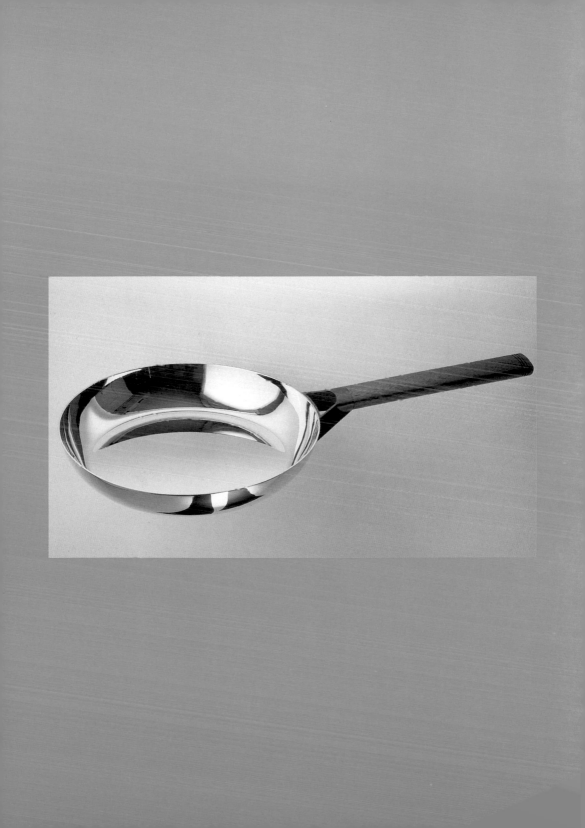

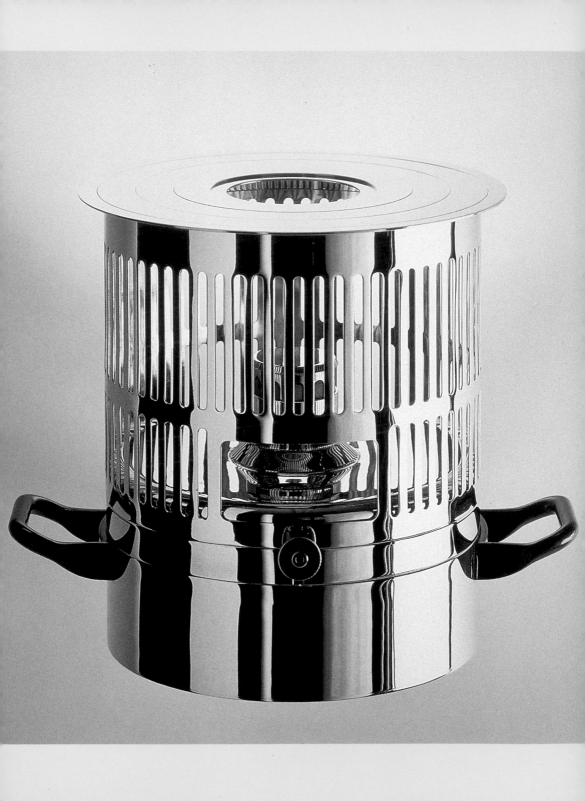

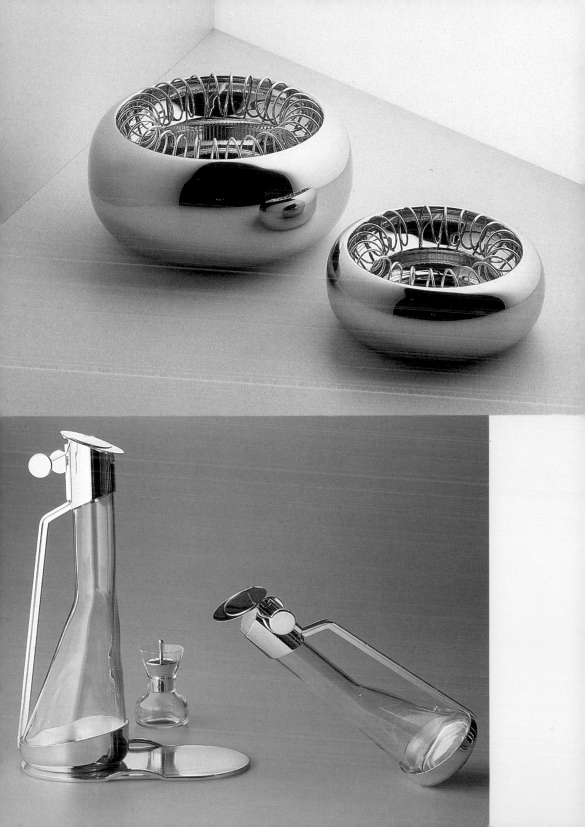

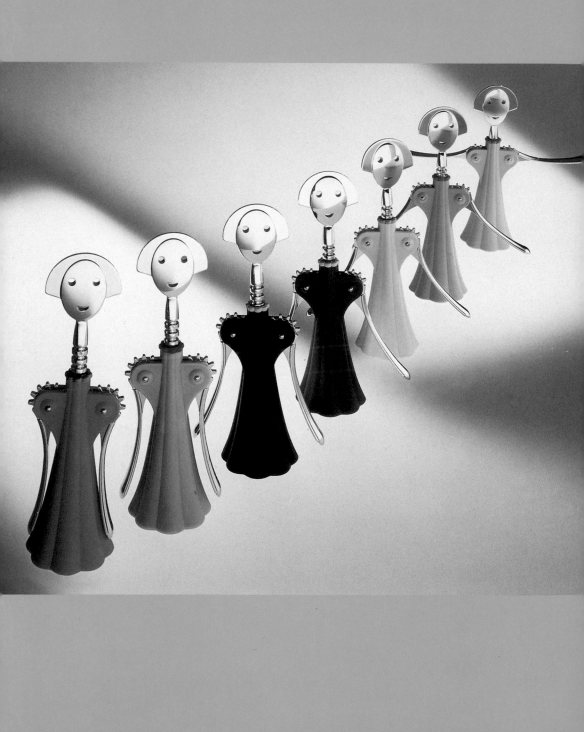

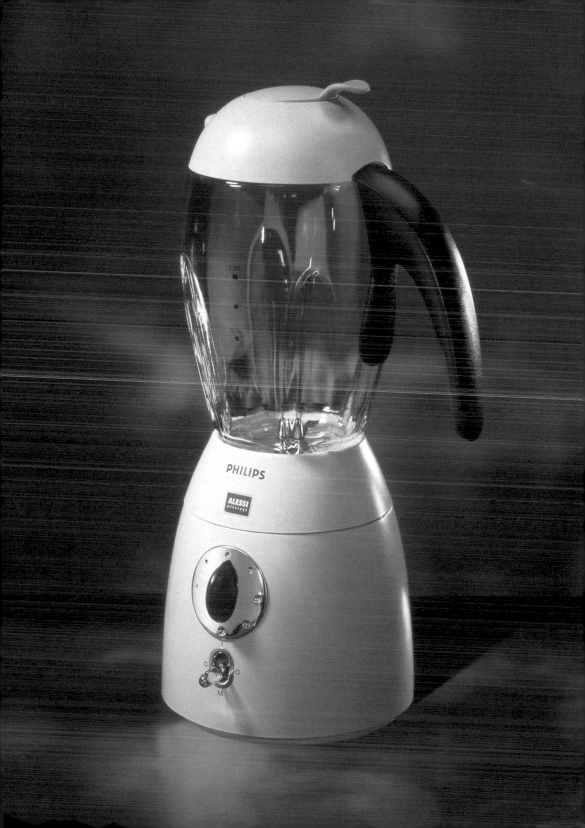

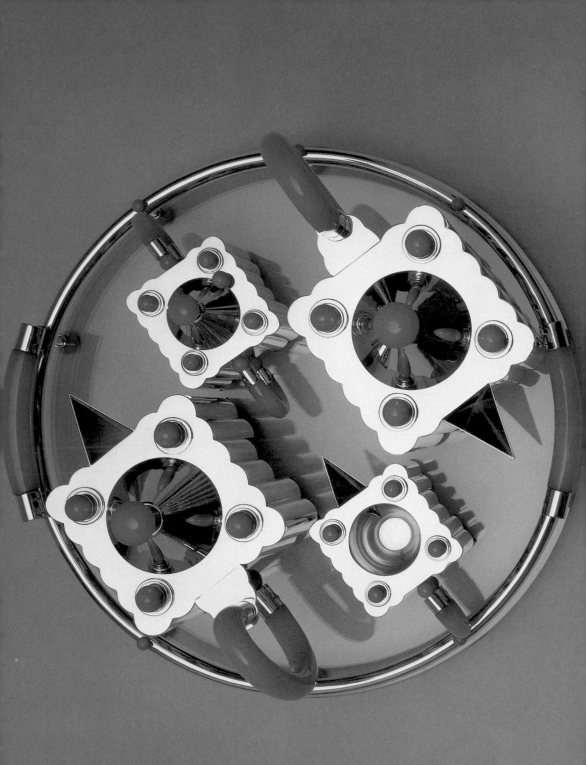

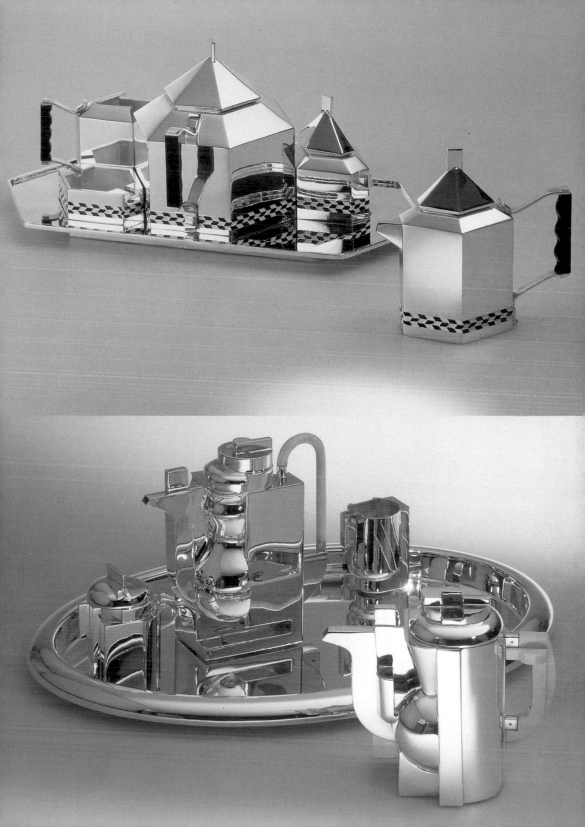

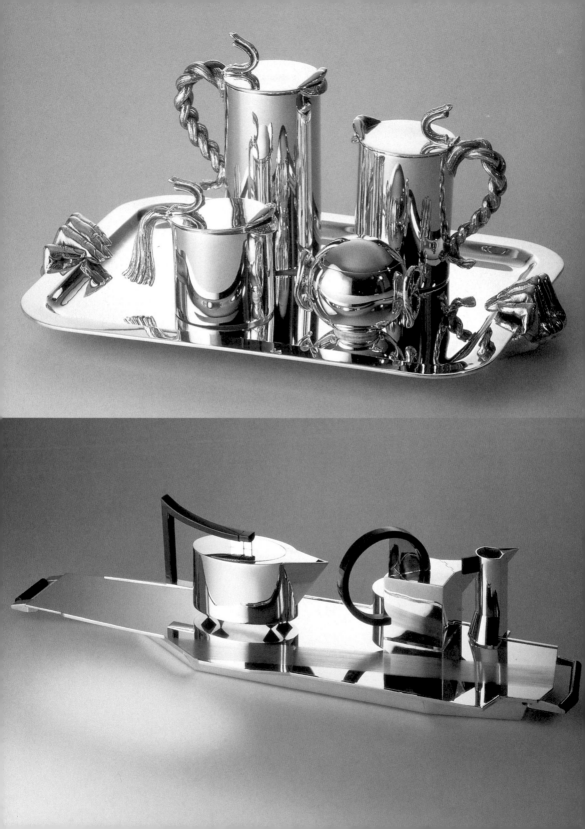

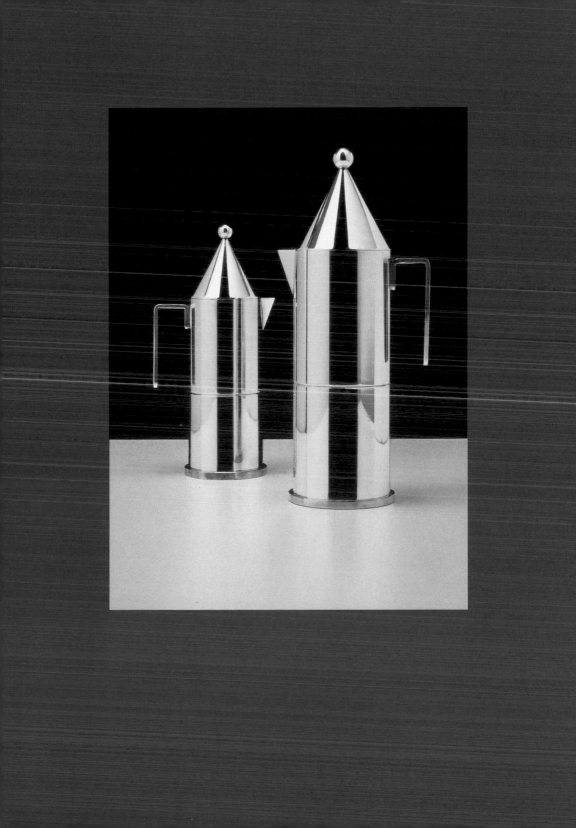

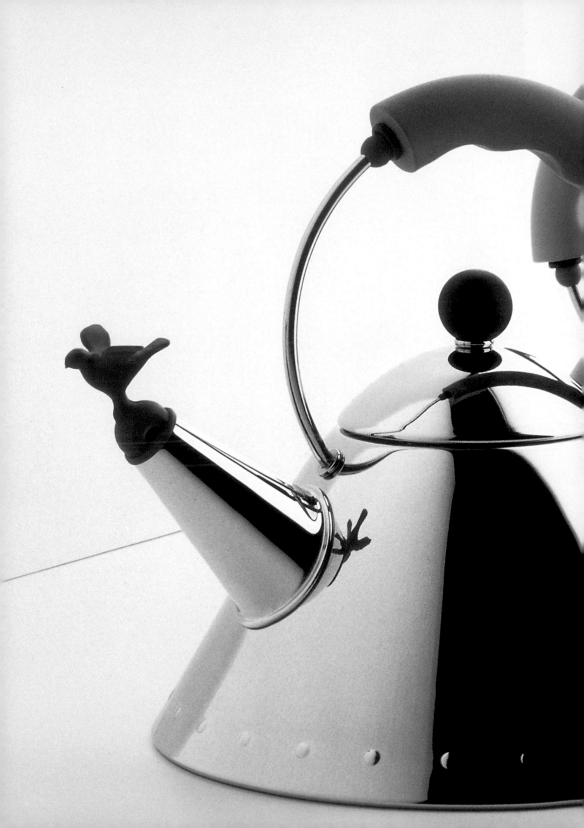

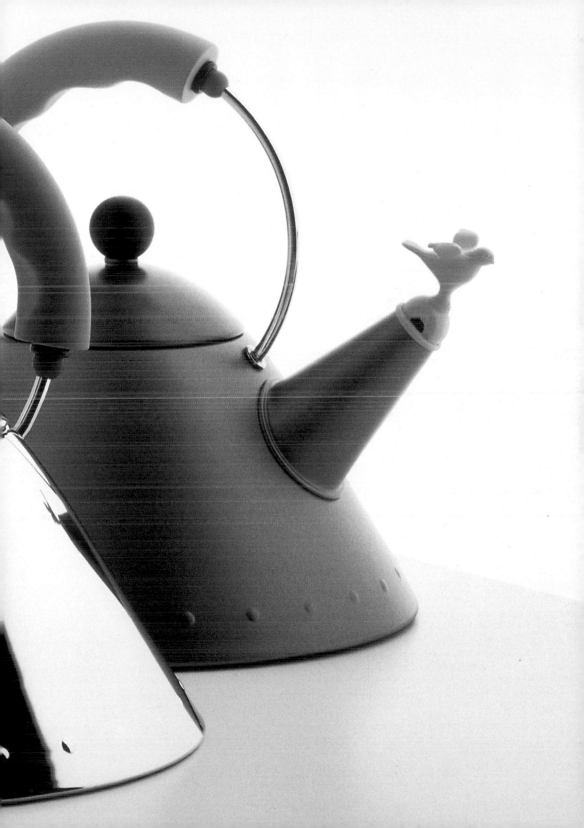

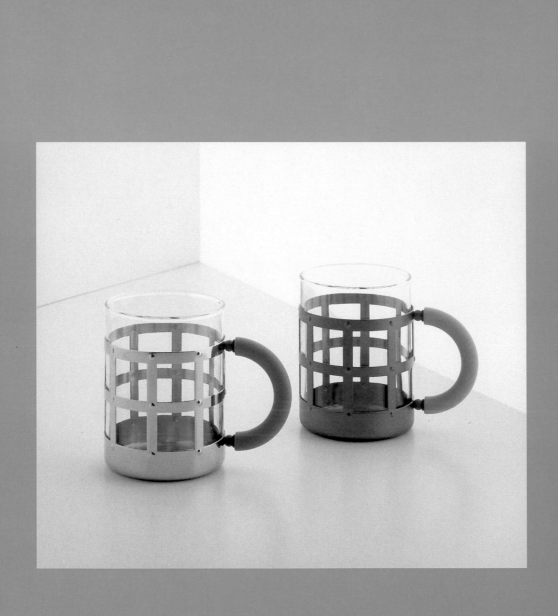

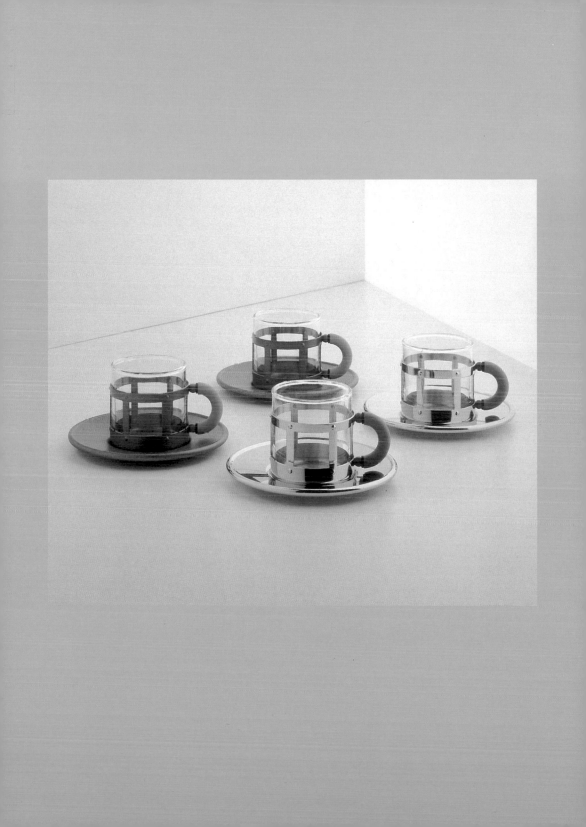

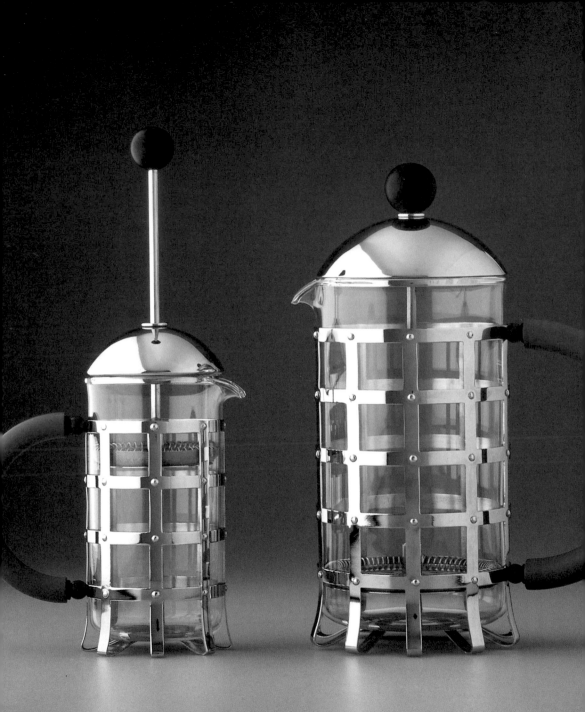

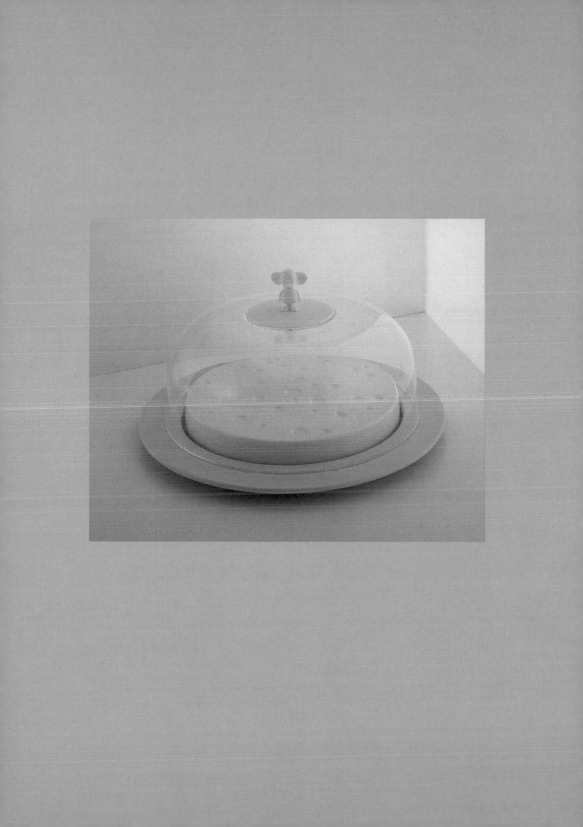

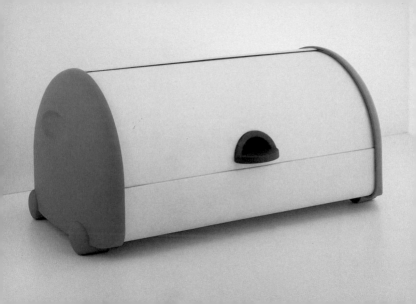

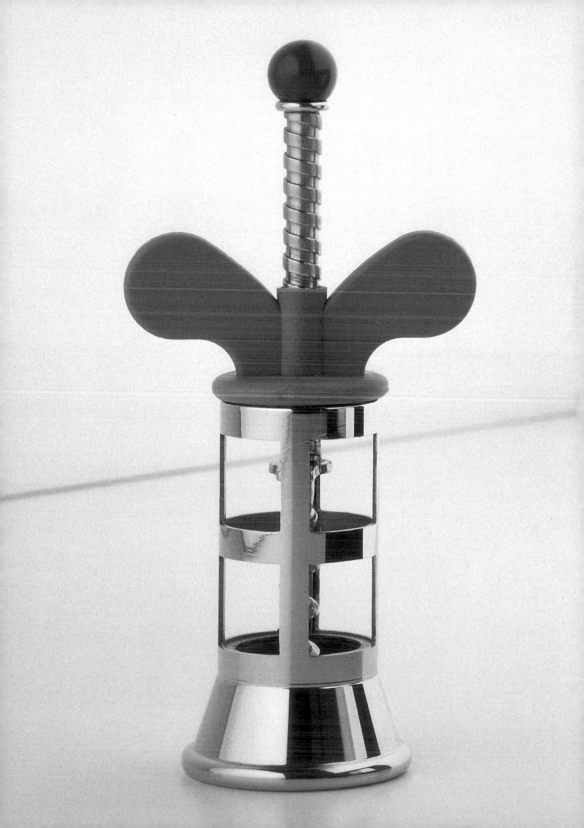

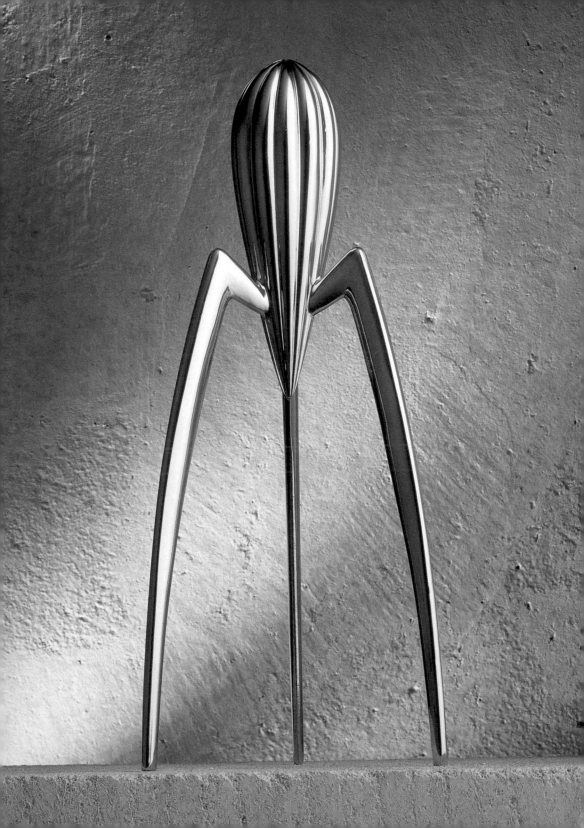

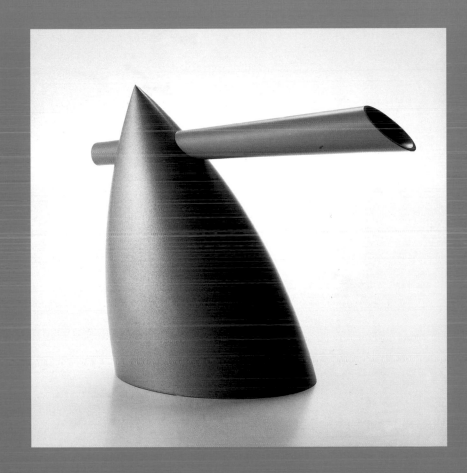

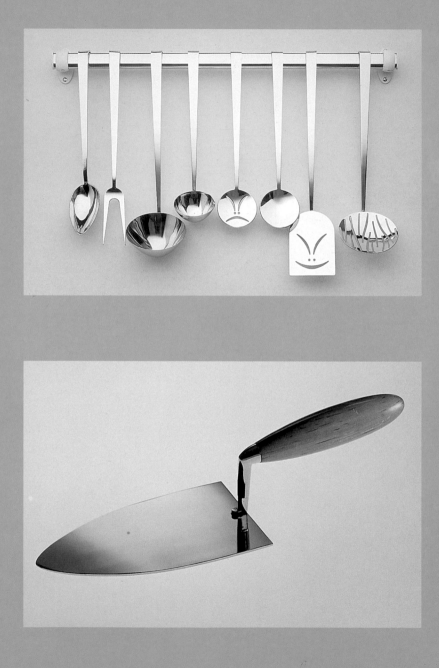

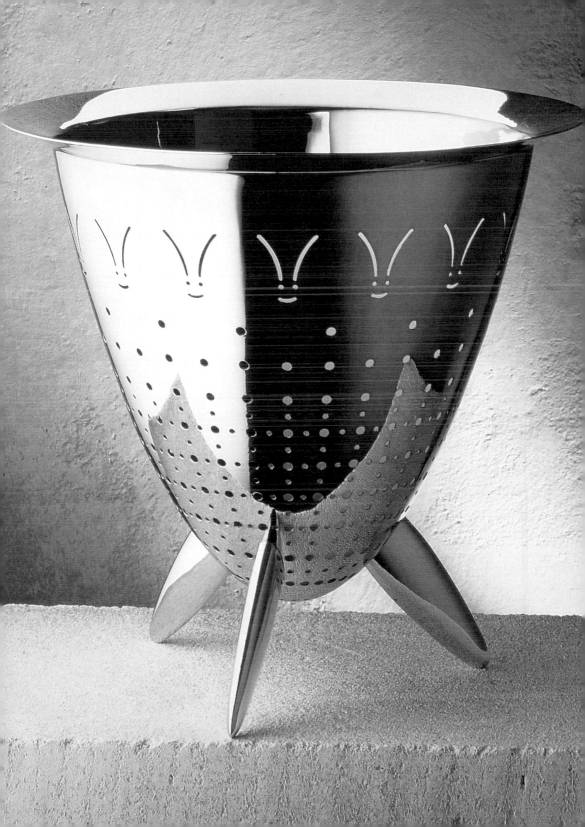

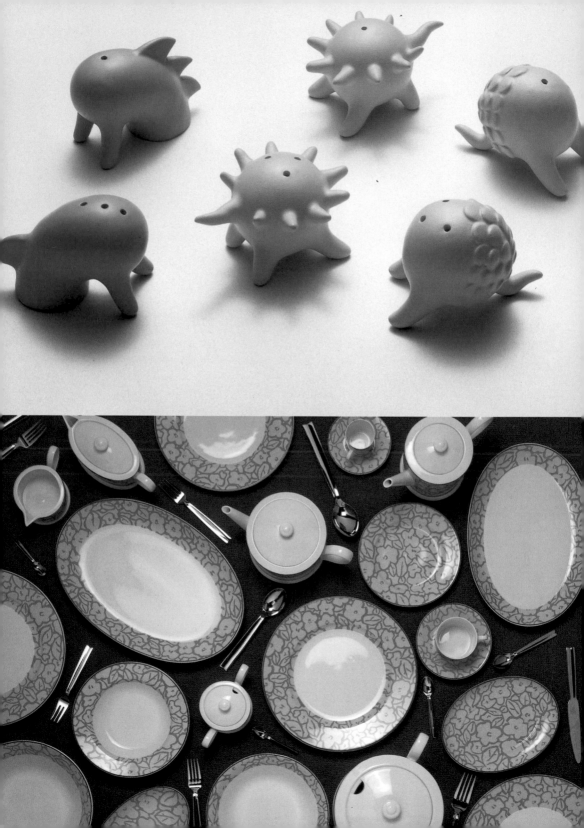

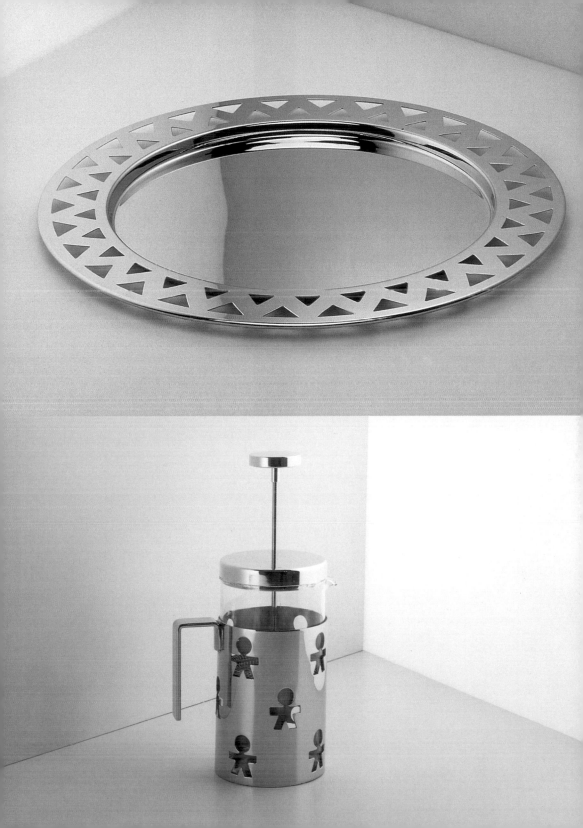

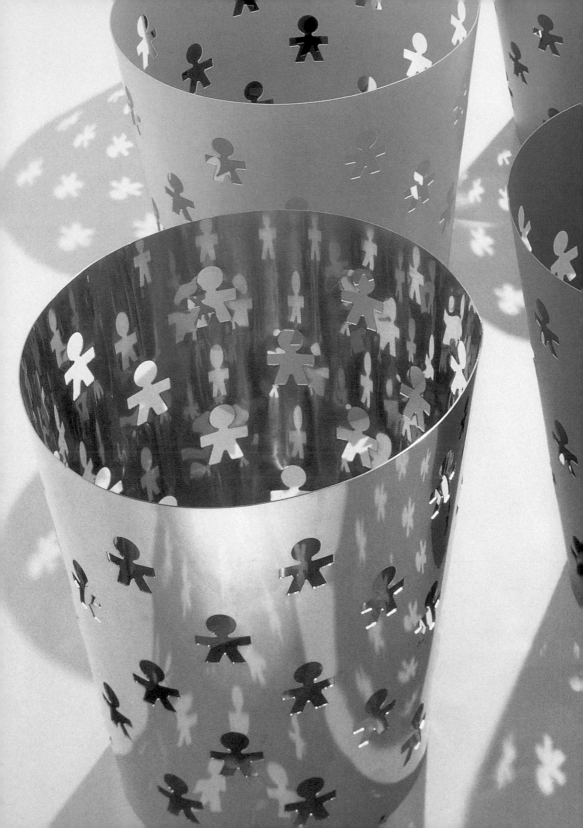

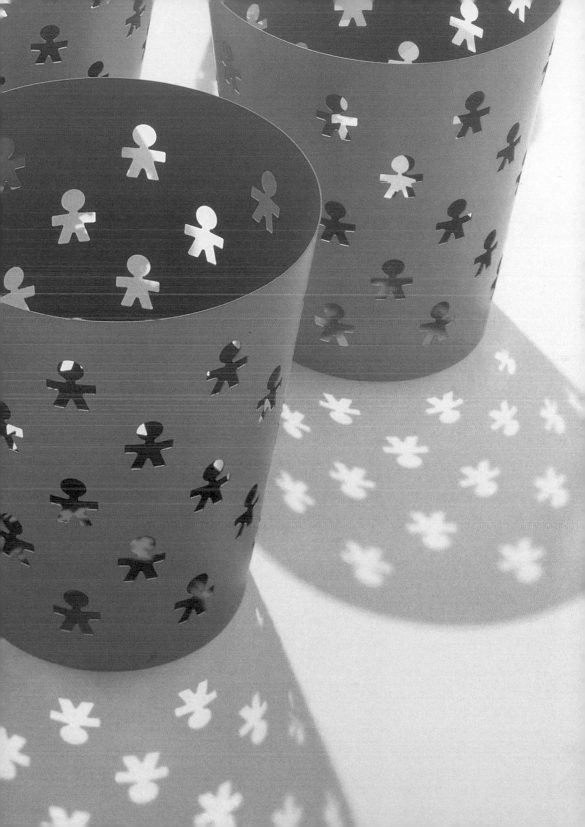

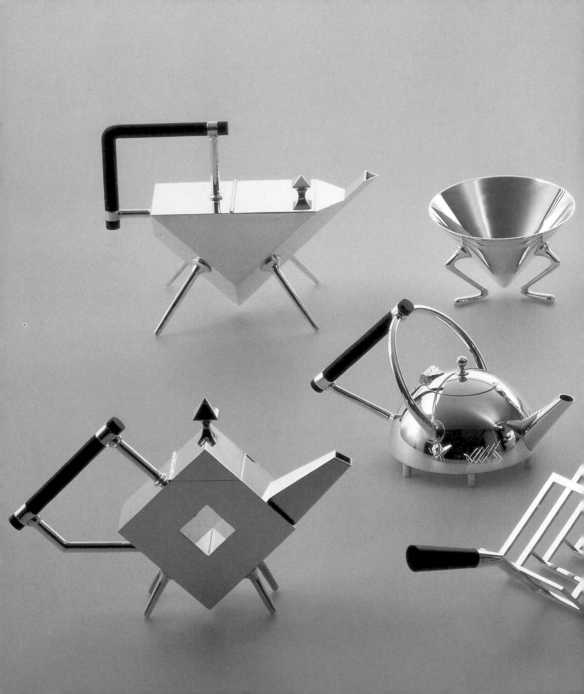

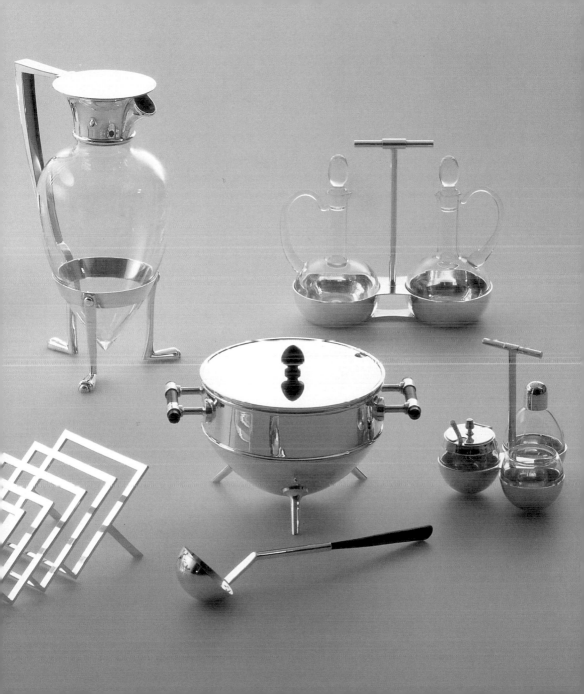

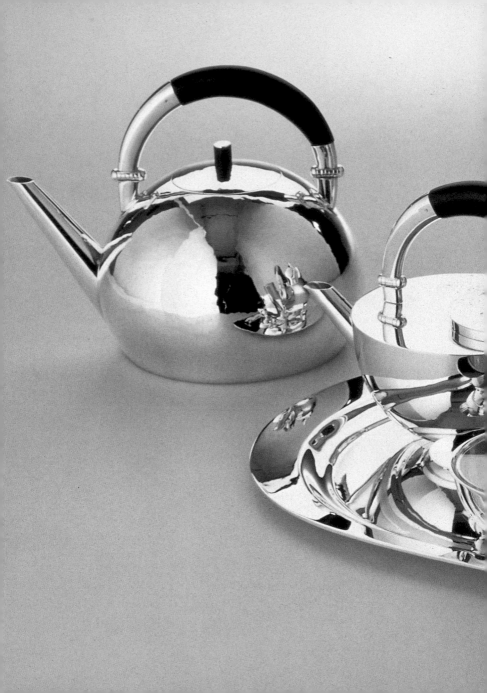

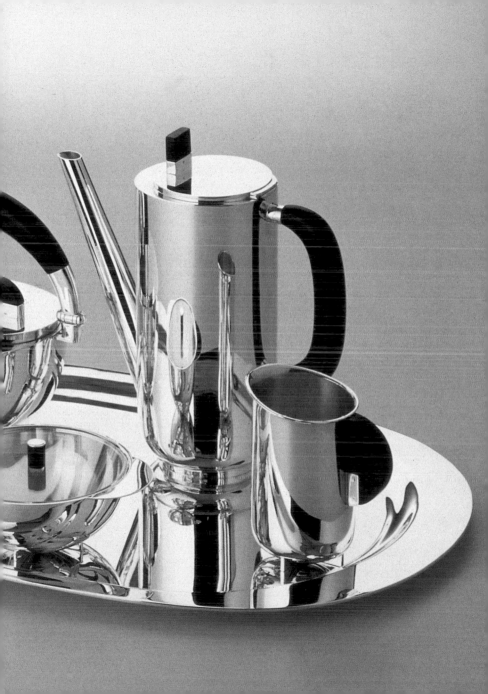

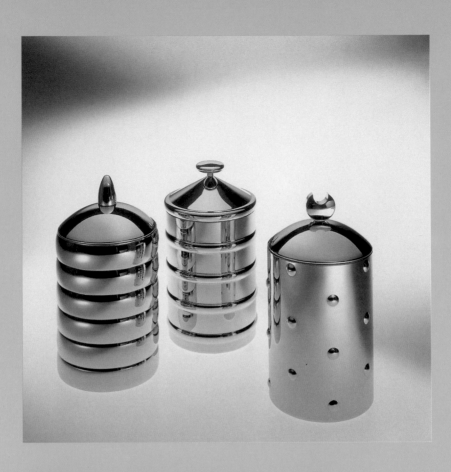

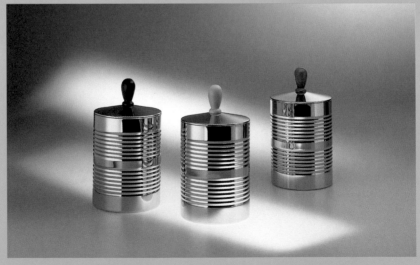

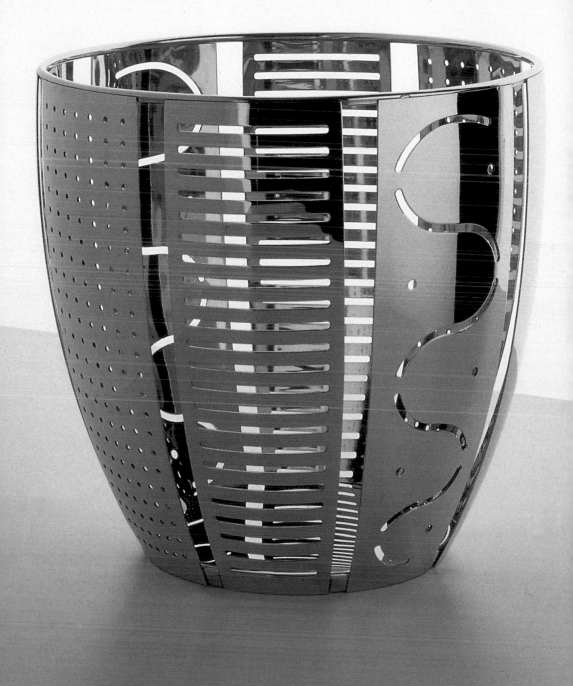

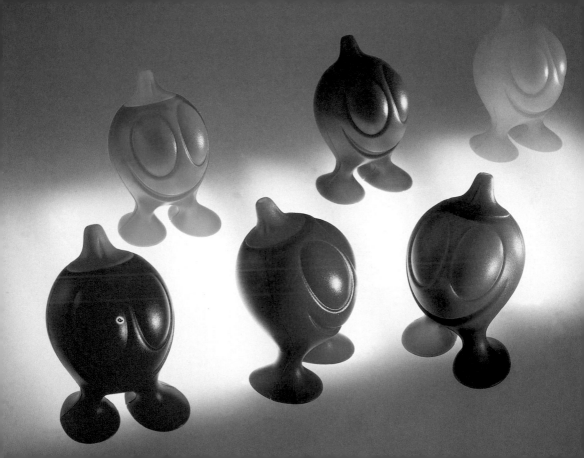

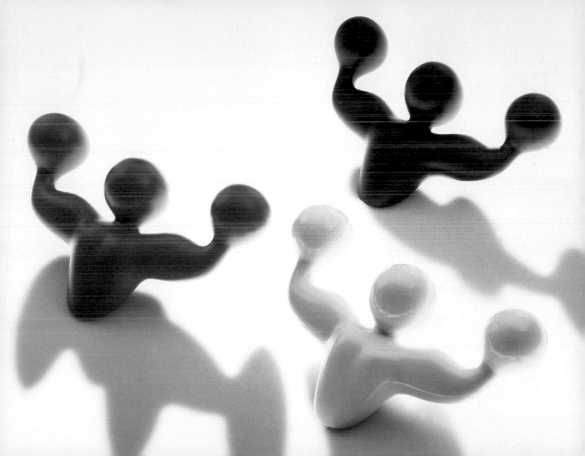

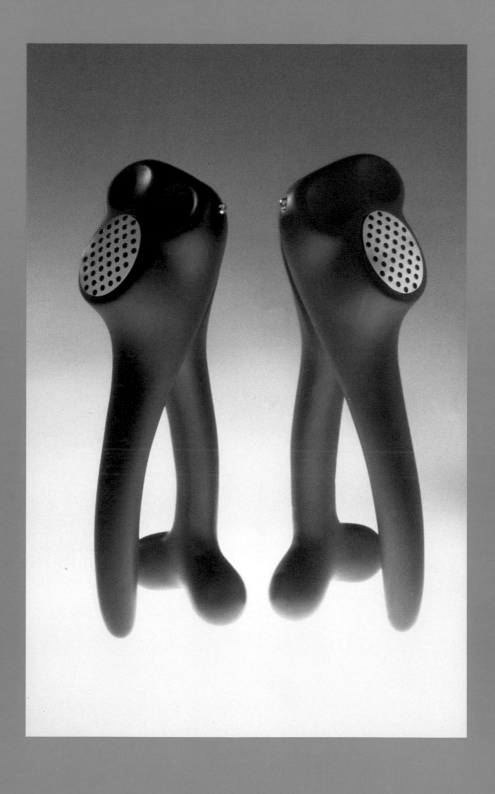

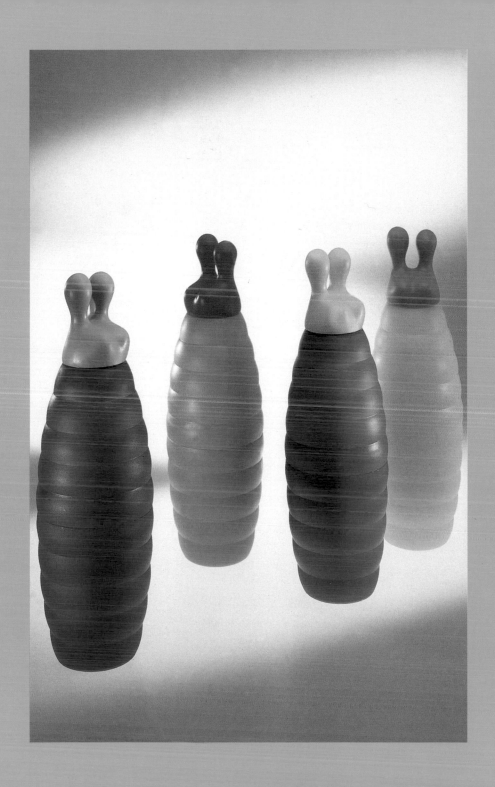

"KING KONG" WASTEPAPER BINS

Series Designed by Designed by Giovannoni and Venturini, from 1989–1990 onwards.

"ANNA G" CORKSCREW

Designed by Alessandro Mendini, 1994.

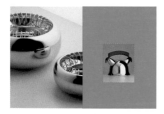

"SPIRAL" ASHTRAY/"MAMA O" KETTLE

LEFT: Designed by Achille Castiglioni, 1970. The first employment of a "maestro" designer, the ashtray is typical of an era when ergonomics mattered and people still smoked.
RIGHT: Designed by Andrea Branzi, 1992.

"KING KONG"

Metal plate with a triangular motif, 1994.

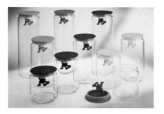

"GIANNI"

By Mattia di Rosa, 1994. Pressure caps in a range of coloured plastics, with glass storage jars. Latin languages have an ancient history of diminutives, and this one is subtitled "a little man holding on tight".

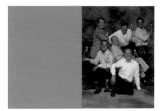

ALESSI FAMILY

Alessi family holding Starck's "Juicy Salif": Carlo; his brother Ettore; his nephew Stefano and Carlo's three sons, Alberto, Michele and Alessio with one of their (dys) functional "children" the Starck juicer of 1990.

ALESSI PRODUCTS

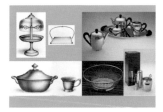

LEFT: Automatic cake holder, 1931; Cheese Board, 1929; Vegetable Dish and Soup Cup, 1930; Ufficio Tecnico Alessi.
RIGHT: top, Bombé Tea and Coffee Service, Carlo Alessi, 1945; bottom, Round wire basket, Ufficio Tecnico Alessi, 1951; Cocktail Service by Luigi Massoni and Carlo Mazzeri, 1957.

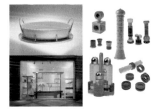

ETTORE SOTTSASS/"TWERGI"

LEFT: Oven-to-table porcelain dish by Ettore Sottsass, 1994; Alessi's Milan showroom by Sottsass, 1987
RIGHT: The "Twergi" range includes some excellent design by Michael Graves, Pepper Mills 1993–5 and the (re)design by Sottsass of his condiment set, and wood Pepper mills, 1989.

"TWERGI"

LEFT: Flower vases by Paolo Grasselli, 1987.
RIGHT: Adalberto Pironi designed a steel and wood Trolley in 1997 – a rare Alessi excursion into the bigger world of furniture.

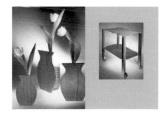

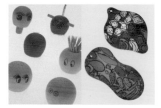

"TWERGI"

LEFT: Simple, yet comic pick holders and bottle stoppers by David Rooz, 1995
RIGHT: Cutting boards, 1996, free flow form and patterns reflect the fashion for revival of formica and melamine from the 1950s.

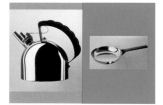

RICHARD SAPPER

LEFT: Stainless steel kettle; with retractable revolver like spout, the kettle produces the sound of an American stream locomotive. RIGHT: Flambé pan resulting from Sapper's collaboration with eminent chefs as part of *La Cintura di Orione* project of 1984–86.

LAMP/"SPIRAL" ASHTRAY, CRUET SET

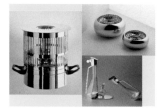

LEFT: Lamp designed by Richard Sapper in collaboration with chef Angelo Parucucchi.
RIGHT: Castiglioni's 1970 "Spiral" ashtray (top); bottom, his 1984 cruet set: the lids rise automatically as a result of a counterweight.

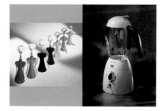

"ANNA G" CORKSCREW/MIXER

LEFT: Designed as a mascot for the fruitful Alessi-Philips projects of 1992–4. A giant version greets visitors outside the Alessi headquarters in Crusinallo. RIGHT: Alessi-Philips mixer, by Mendini and Stephano Marzano, 1994.

"TEA AND COFFEE PIAZZA"

LEFT: silver set for Michael Graves. Viewed from above, the image of a Piazza with buildings is reinforced. RIGHT: silver set by Paolo Portoghesi (top) and Richard Meier. All 1983.

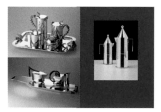

"TEA AND COFFEE PIAZZA"/"LA CONICA"

LEFT: Further examples of the series by Stanley Tigerman and Hans Hollein, 1983. RIGHT: Coffee maker designed by the late Aldo Rossi in 1982, and produced from 1984 in stainless steel. Rossi's work for Alessi was as a result of the postmodern debate.

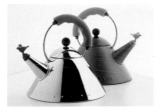

KETTLE "9093"

Designed by Michael Graves, 1985 the icon of the postmodern mid-1980s, this "singing" stainless steel kettle with polyamide handle and red bird-shaped whistle sold over 40,000 in one year in the 1980s and brought fame to both Graves and Alessi.

"DEMITASSE"

By Michael Graves, 1989, who may well prove to be Alessi's greatest designer of the 1980s. Here he has designed an open lattice work with rivets, in stainless steel, a knowing tribute to the forms deployed by Josef Hoffmann and other Wiener Werkstätte designers at the beginning of the century.

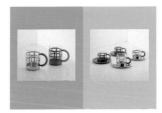

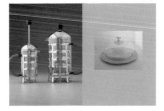

"DEMITASSE"/CHEESE BOARD

LEFT: "Demitasse", cafetiere. RIGHT: Since Graves has been designing for The Walt Disney Company in the 1990s, the cheese board is as near as Alessi can get to the "Mouse" itself! The cutting board is ceramic, in imitation of a "Swiss" cheese.

BREAD BIN/CORKSCREW

LEFT: Graves has revamped an article that has hitherto been rather neglected and dull, 1997. RIGHT: The wing-shaped corkscrew, 1993, functions well and sets up a resonance with Graves' fascination with Disney – and the ears of the famous mouse.

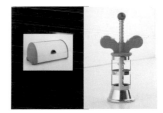

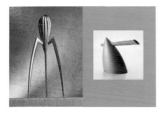

"JUICY SALIF" SQUEEZER/"HOT BERTAA" KETTLE

LEFT: Typical of Starck's approach, which is to use three legs, rather than four, 1990. RIGHT: Another highly styled design. It has not been a success, despite managing to look like a streamlined propeller and one of Madonna's pointed corsets at the same time, 1990.

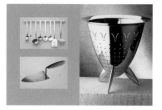

PHILIPPE STARCK

LEFT: "Faitoo" kitchen tools, 1996 (top). Starck has at last designed something really useful for Alessi with this factotum kitchen tidy. "Ceci n'est pas une truelle" (bottom), cake slice, 1998. RIGHT: Max le Chinois colander, 1990.

"TENDENTSE"

LEFT: "Gli Uni" salt and pepper sets by Alejandro Ruiz, 1993 (top); "Cottage Garden" tableware by Michael Graves, 1994. RIGHT: "Ginevra" glass by Ettorre Sottsass, 1996 (top); "Jaia" bowls by George Sowden, decorated by Natalie Du Pasquier/A Forilli, 1997.

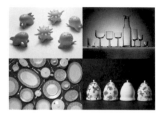

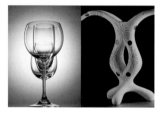

"TENDENTSE"

LEFT: "Orseggi" drinking glasses by Achille and Piergiacomo Castiglioni, 1997, a revamp of a 1960 design by these famous brothers. RIGHT: "Cro" vase by Anna Gili, 1985.

"100% MAKE UP"/"KING KONG 'GIROTONDO'"

LEFT: 100% Make Up vases clockwise from top left, No 84 by Cyprien Tokoudagba; No 98 by Young Aspirations Young Artists; No 51 by Kamba Luesa and No 41 by Bodys Isek Kingelez, 1992. RIGHT: "King Kong" plate and cafetiere.

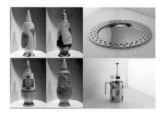

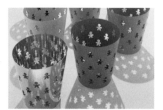

"KING KONG 'GIROTONDO'"

Designed by Giovannoni and Venturini, from 1989-90 onwards. At first made of metal, these childlike designs have evolved, towards plastic ice cube moulds and inexpensive wax candles.

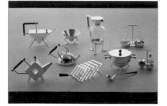

"ARCHIVI"

Range of silver artefacts by Christopher Dresser (1878-1885), 1991. Produced silver, in limited edition. The objects give only a partial view, as Pevsner did in the 1930s, and perpetuate the myth that Dresser was a "pioneer" of "modern" design.

"ARCHIVI"

Tea Service by Marianne Brandt, (1924), 1985. Produced in silver, under license of the Berlin Bauhaus-Archiv. On one level this is a good museum replica; on another it locates the Alessi "family" of artefacts back to the "mother" and "origins".

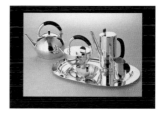

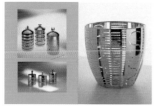

MEMORY CONTAINERS

LEFT: "Kalisto" kitchen boxes by Clare Brass, 1992, an intelligent suite of lidded kitchen boxes (top). "Tin Man" kitchen boxes, by Constantin Boym, 1994. RIGHT: "Helmut Citrus" basket by Cecilia Cassina, 1992.

"GINO ZUCCHINO"/"ANTONIO"

LEFT: Sugar sifter in coloured plastics by Guido Venturini, 1993. A cartoon character that embodies child codes, or suburban neo-kitsch, as sweet as that the sugar which it contains? RIGHT: Venturini's coat hook available in a range of coloured plastics, 1996.

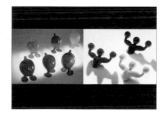

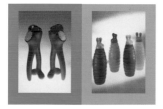

"NONNO DI ANTONIO"/"FRED WORM"

LEFT: Venturini's 1996 garlic press. Again anthropomorphism, child codes and a more adult lasciviousness collide like circus clowns. RIGHT: Venturini's multicoloured vacuum flask in plastics, 1996.

Picture Credits

Carlton Books Ltd. would like to thank Alessi S.p.a./FAO S.p.a. for their kind permission to reproduce the pictures in this book.

The Publishers wish to express their sincere gratitude to Cristina Franchi at Alessi S.p.a. for the time and assistance she has contributed to this project.

Every effort has been made to acknowledge correctly and contact the source and/copyright holder of each picture, and Carlton Books Limited apologizes for any unintentional errors or omissions which will be corrected in future editions of this book.

Footnotes

1 Walter Benjamin, The Paris of the Second Empire in Baudelaire, 1938. Quoted from *Charles Baudelaire*, Walter Benjamin, Verso, London, 1989 p. 105.

2 *Steel & Style*, Patrizia Scarzella, Arcadia, Milan, 1985, p. 18.

3 *Steel & Style*, op.cit, p. 95.

4 *The Dream Factory*, Alberto Alessi, Könemann, Cologne, 1988, p. 57.

5 *The Dream Factory*, op.cit, p. 57

6 *The Dream Factory*, op.cit, p. 95

7 *La Cucina Elettrica*, Raffaela Polettii, Electa, Milan,1994, p.187.

8 *The Dream Factory*, op.cit, p. 93

9 *The Dream Factory*, op.cit, p. 105

10 *The Dream Factory*, op.cit, p. 91

11 *Five Faces of Modernity; Modernism, Avant-Garde, Decadence, Kitsch, Postmodernism*, Matei Calinescu, Durham, North Carolina: Duke University Press 1987, pp. 229–30

12 *The Independent*, from an article titled "The Mouse that Ate Western Civilisation", Gilbert Adair, London, October 14, 1998.

13 *Faking It: Sentimentalization of Modern Society*, Digby C. Anderson and Peter Mullen, Social Affairs Unit, London 1998, p. 61.

14 *The Independent on Saturday*, from an article titled "How the American Dream Turned into a Nightmare", Elizabeth Nickson, London, August 1998, pp 12–16.

15 *New Yorker*, from an article titled "In the Aisles – a Postmodernist Goes Shopping", Paul Goldberger, New York, February 1, 1999, pp. 23–24.

16 *Investors Chronicle*, London, 12–18 March 1999, pp. 67.